A WORLD REDRAWN

Eisenstein and Brecht in Hollywood

Edited by Zoe Beloff

with essays by

Hannah Frank

and Esther Leslie

CHRISTINE BURGIN | NEW YORK

WALT DISNEY PRODUCTIONS *Ltd.*

MICKEY MOUSE
TRADE MARK · REGISTERED
SOUND CARTOONS

2719 HYPERION
HOLLYWOOD

April 11, 1935.

Mr. Sergei Eisenstein,
Tchistiye Prudi 23, Apt. 2,
Moscow,
United States Soviet Russia.

Dear Mr. Eisenstein:

Thank you for your letter of March 16, supplementing your con-
gratulatory cable to us of March 4th, with respect to the
prize awarded our films.

Needless to say, we are very happy that our pictures were deemed
worthy of this honor, and we are deeply appreciative of the good
will exhibited by the people of Russia toward our product.

With reference to the Kino Photo Publishing House publishing a
book from some of our scenarios, I am referring this part of
your letter to my brother, Mr. Roy Disney, who handles all the
business matters of our organization. I understand he has al-
ready written you regarding this subject.

I also understand from my brother that negotiations are under way
for the sale of some of our pictures in Russia. We are very hope-
ful of securing distribution of our pictures there, but at this
time it seems they are only interested in a very few films, and
these to be on an outright sale basis.

Please accept my thanks and appreciation for your interest in
our product.

With kind personal regards and all good wishes, I am,

Sincerely yours,

Walt Disney

Walt Disney

WD:DV

SILLY SYMPHONY
Sound Cartoons

CONTENTS

Letter from Walt Disney to Sergei Eisenstein thanking him for voting *The Three Little Pigs* best film at the First Moscow International Film Festival. Ultimately the film was awarded a "special prize."

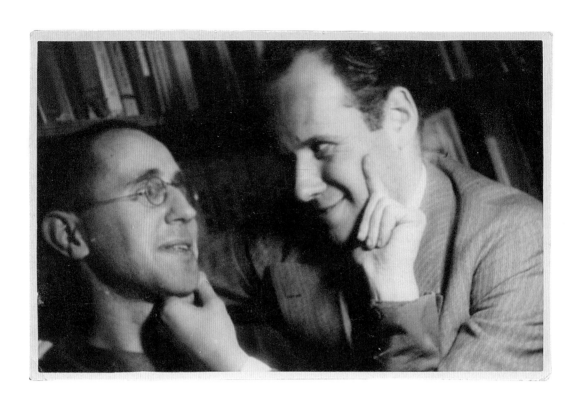

A WORLD REDRAWN

Zoe Beloff

TIME LINES

It is early summer. We wait on a quiet side street in a residential neighborhood far from the center of Moscow. It is nine o'clock in the morning. We are outside an old building. The great wooden door is scarred by many snowfalls. Weeds sprout through cracks in the steps. Trees enshroud the upper stories. Only a few potted plants on a window ledge suggest that the building is inhabited. I wonder, is this the right place? There is a small plaque by the door that reads RGALI, the Russian State Archive of Literature and Art. Perhaps it has moved and I have an old address. Finally a few people arrive. We are sent around to the back entrance, a path through the trees. Inside the door sits a guard at an ancient computer. She is dressed in high heels, a pencil skirt, and a bulletproof vest and with a blond upswept hairdo and a military hat. She is armed. Our translator tells me she is very sweet.

We still have much bureaucracy to traverse. Finally we are issued bright yellow identification passes and baby blue bootees to cover our shoes. We enter the small reading room. A pile of folders is placed on the desk. Inside are notes written on onionskin paper, on hotel stationery, on typing paper, snapshots, and drawings in pen, pencil, and crayon. I hold in my hands sketches by the Soviet film director, artist, and theorist Sergei Mikhailovich Eisenstein for a film that he never made while on a journey to America that the history books tell us ended in failure. On his return to Moscow, Eisenstein wrote, "My notes — languished in a suitcase at the hotel and were eventually buried Pompeii-like, beneath a mass of books while they waited for realization."[1] But as I excavate them here in the archive, they are filled not with the dust of history but with promise, with life, with potential.

How can I explain my relationship with history and with time? A couple of years ago, a historian from Harvard asked me what my methodology was.

Sergei Eisenstein and Bertolt Brecht during a visit to the playwright S. M. Tretyakov in Moscow, 1935.

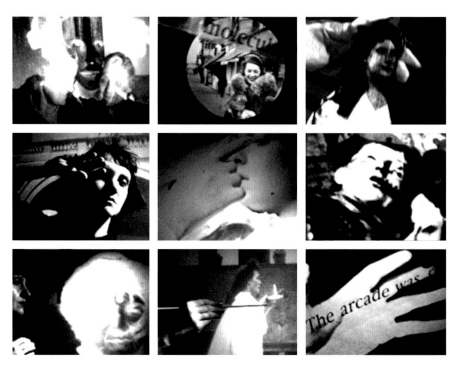

Zoe Beloff, stills from the CD-ROM *Beyond*, 1997.

Since I'm an artist not an academic, this question was a first for me and quite naively and spontaneously I said, "Oh, I talk with people in the past." It was only then that I discovered not all historians do this, certainly not in the way that I do, perhaps because they view them as objects of study rather than as comrades and collaborators.

Ever since I began working on my project *Beyond* in 1995 I have been redrawing time lines. *Beyond* is a Web-based interactive work, an exploration of the paradoxes of technology and the unconscious posed since the birth of mechanical reproduction. The viewer enters into a virtual world of ruined, bombed-out buildings, the wreckage of history. I am the guide, the "interface" between the living and the dead. My medium was an early webcam that created flickering black-and-white movies the size of postage stamps. I filmed myself amidst the discarded fragments of the past. I would report conversations with philosophers and artists, from Baudelaire to Henri Bergson to Walter Benjamin. I wanted to find out what we could learn

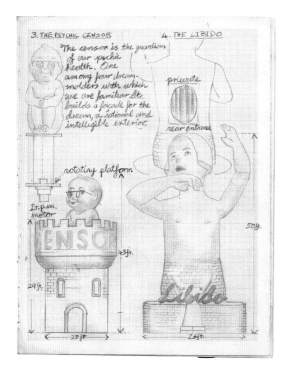
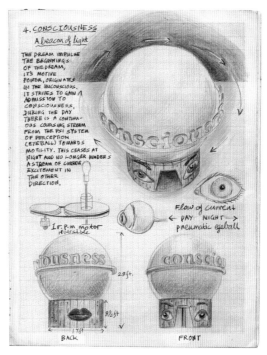

Elevation drawings by Albert Grass for three Dreamland Pavilions: "The Psychic Censor," "The Libido," and "Consciousness."

from them at the dawn of the digital era. I believed it was a matter of some urgency. Sometimes they were hard to hear. I imagined past and present connected by a hotline, prone to static, to vibrations in the ether, connecting two early technologies, a long ago telegraph office and the dial-up modem. *Beyond* was a record or sketchbook of my thought process as it happened. One line of research led to another, one text to another. It was a first draft of everything that I would go on to create, an attempt to map out new pathways between past and present that might productively point the way to the future.

In 2009 if you had found yourself at Coney Island amusement park and were willing to fork out 99 cents for a ticket to the Coney Island Museum you would have seen my exhibition *Dreamland: The Coney Island Amateur Psychoanalytic Society 1926–1972*. One of the things you would have discovered were drawings and plans by the founder of the Society, Albert Grass, for a Freudian theme park. These drawings illustrate a series of pavilions; *The Unconscious*, *The Dreamwork Factory*, *The Psychic Censor* are

linked by a *Train of Thought* that revolves around a fifty-foot-high *Libido* in the form of a prepubescent girl.[2]

Albert Grass's projects manifested my own interest in the way architecture can reveal social structure. I was inspired by the way in which Rem Koolhaas describes Coney Island as a concrete articulation of the collective unconscious through irrational architecture and performance in his book *Delirious New York*. And by Siegfried Kracauer, who wrote in 1930, "Spatial images are the dreams of society. Wherever the hieroglyphs of a spatial image are deciphered, there the foundations of social reality may be identified."[3]

Some visitors insisted that they remembered Grass's drawing of Dreamland from their childhood; others declared that the whole archive of the Coney Island Amateur Psychoanalytic Society was a hoax. I on the other hand consider my project a serious history, just not a literal one. It was in fact based on a carefully researched social history of the Coney Island community during the twentieth century. At the same time, I conceived of it as a work of psychoanalysis aimed at bringing to light the latent potential buried in this history. I think of the Coney Island Amateur Psychoanalytic Society as a group of working-class utopians. They understood psychoanalysis politically and poetically. While socialism might liberate them from oppression from the outside, psychoanalysis would liberate their psyches from the tyranny of class and of the cultural and sexual mores of their time. My project was a proposal for a social space where everyone can change his or her life in ways both playful and serious.

The members of the Coney Island Amateur Psychoanalytic Society were fictitious but soon I was to bring together another band of amateurs who were very real. In 2012 in solidarity with Occupy Wall Street, I put out a call for performers to stage Bertolt Brecht's play *The Days of the Commune* in public spaces all around New York City. The Paris Commune of 1871 was the first great occupation in modern history where the workers took over their city and set up a radical new democracy based on equality and sharing. Three months after it began the Commune was destroyed by the government of France.

The performers I brought together and I were a ragtag brigade. I made all the scenery and props out of cardboard because I wanted to make visible the idea that history is always something that we ourselves construct. Brecht understood the Paris Commune as a project that remains unfinished. Indeed I conceptualized our public rehearsals as just that, a rehearsal for a commune

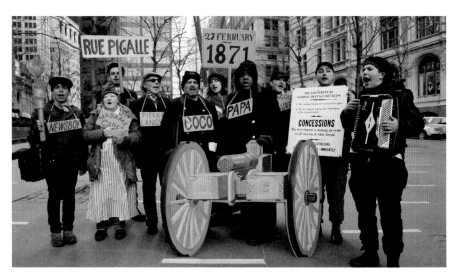

Zoe Beloff, still from the film *The Days of the Commune*, 2012.

yet to come. All my projects, modest in scale, made with whatever resources were available, aim to draw new connections between past and present to help us imagine a future against the grain of reactionary forces.

Today more than ever history is contested territory. We only have to look around us to see southerners rallying to the Confederate flag or Vladimir Putin building replicas of the Russian Orthodox churches destroyed by the Bolsheviks or paying for a brand-new statue of Czar Nicholas II in Belgrade. In my brief visit to Red Square I saw quite a number of young men with portraits of Stalin on their T-shirts. They were not ironic. The ghosts of the past are not dead, and as they walk among us they have very real effects.

Walter Benjamin described very well how history is not something fixed and eternal. "Articulating the past historically does not mean recognizing the past 'the way it really was.'" He passionately declares that "the 'eternal' past of the historicist" is just sentimental rubbish. The task of the historical materialist is to blast a specific event or work out of time in order to see it anew.[4] He invites us to rethink history as an act of liberation, to proceed in the spirit of irreverence.

I think the best place to start is with fragments—ideas cut short, abandoned, victims of forces beyond their control, forces of culture, politics, and economics. Let us set forth armed not with leather-bound tomes of accepted ideas but with jottings on scraps of paper or notebooks that fell

victim to irrational optimism or terrible purges, like the people who created them, uprooted, flung across continents. Some are buried in archives, others lost forever, like the briefcase Walter Benjamin took on his final flight to Spain.

I find myself drawn back to a certain time in history, roughly from the 1920s through the 1940s. I believe we can learn from the work of artists and filmmakers who attempted to communicate with a mass audience in a way that was both critical of the status quo and optimistic in that they wanted to show how things could be other than they are.

Even before I staged *The Days of the Commune*, I felt that Brecht might have something to tell us about what was going on today. He was a German poet, playwright, and theater director. He was also a Marxist. Though his plays have humor, tragedy, and music, he did not want to make theater that was simply escapist entertainment for those who could afford expensive tickets. Instead his plays invite us to think about the events onstage in relation to what is happening in our lives. But rather than telling us how to live, the plays raise questions. They invite us to think for ourselves and inspire us to change the world.

Brecht lived in Los Angeles from 1941 to 1947 in exile from the Nazis. I thought that this might be the best place to ask him questions about what is going on in our country today. He tried writing screenplays to earn a living. When I read that he had written more than fifty unrealized treatments I wanted to find out more. I knew that a few years earlier the great Soviet filmmaker Sergei Eisenstein also tried and failed to make films in Hollywood.

Eisenstein, like many of his fellow artists after the Russian Revolution, wanted to create new forms of art that would take part in shaping a new society. His famous 1925 film *Battleship Potemkin* is based on a mutiny of Russian sailors in 1905. The story is told through a radical new film language that he called montage but it was also a great spectacle with crowd scenes and bloodshed. *Battleship Potemkin* took the film world by storm. The left-leaning artists in Europe loved it. The movie moguls in Hollywood saw a blockbuster and they wanted more. In 1930 Eisenstein arrived in Los Angeles with a six-month contract from Paramount Studios.

Eisenstein and Brecht had the same ambition, to make films in Hollywood on their own terms. Working in the world's most famous movie factory, they believed that artists must call into question the ways in which we think we understand our world. The studio rejected all of Eisenstein's screenplays.

Brecht was the cowriter of only one movie that was produced, *Hangmen Also Die*. Anticommunist agitation eventually forced both men out of the country.

While the history books conceive of their unfinished work as failure, I would simply say that it is waiting to be realized. I chose to work with two of their film scenarios: Eisenstein's *Glass House* and Brecht's *A Model Family*. I selected them because I felt that their common themes—architecture as a representation of social and economic relations—and their depiction of a world of surveillance and spectacle speak to us today.

No finished screenplay exists for either of these projects. Eisenstein made extensive notes and drawings for *Glass House*. He imagined a film about a great glass skyscraper in which not only the walls but also the floors and ceilings were transparent, a world of total visibility. It would be a satire on American capitalism.

Brecht jotted down only a few ideas, inspired by an article titled "A Model Family in a Model Home" in a 1941 issue of *Life* magazine. It describes how an Ohio farm family spent a week in a model home at the state fair with all of the most modern conveniences. The drawback was that the home was open to the public twelve hours a day, everything was for sale, and even the intimacy of home life was presented as another mass-produced commodity.

Brecht and Eisenstein challenge me, and they give me hope. I think of them as my comrades. They make me feel less alone in my struggle to make sense of the world. To work with their ideas I had to take on several roles. On the one hand I was the ventriloquist or medium through which their ideas might be realized. On the other hand, I felt it important to be the "bad" student, that is, someone who doesn't just sit at the feet of the masters but thinks and talks back. I determined not to make a pastiche of the movies they might have made but instead to rethink their scenarios in the light of the twenty-first century. Only if the films can be relevant now can their ideas be redeemed, and if I cannot do this then I have failed. The archive is only there for us to activate and, if we cannot, it is nothing.

My project, *A World Redrawn*, is a collection of archival objects, films, architectural models, and drawings that form a dialogue structured along two axes: time and space. Malleable and elastic, time stretches back to the 1930s and '40s, when Brecht and Eisenstein were writing, then penetrates still further into their dreams, back into their childhoods, and then forward to today. Space is the physical distance between continents, the space of architectural structure, the space of cultural collision, the virtual space of cinema. All play their part.

THE STRANGENESS OF LOS ANGELES

I began by shooting *Two Marxists in Hollywood*, a film in which Bertolt Brecht and Sergei Eisenstein, both played by child actors, speak about their experiences in Hollywood and their ideas for a new cinema. The text is drawn from their writing during the period in which they lived in Los Angeles.

With its palm trees, balmy weather, and bright colors, Los Angeles feels like a foreign country, even from the perspective of New York, but much more so coming from Europe. And its strangeness must be multiplied exponentially going back seventy or eighty years, before everything began to look and sound and taste the same. But even then Hollywood had created a celluloid America that had colonized everyone's imagination as far away as the Soviet Union. Already in Moscow Eisenstein dreamed of meeting his heroes D. W. Griffith, Charlie Chaplin, and Walt Disney.

Long before he set foot in the United States, Brecht was likewise fascinated by an America that he had seen in movies ruled by sharks on Wall Street and mob bosses in Chicago. He used the gangland idiom to represent the Nazis in his play *The Resistible Rise of Arturo Ui*. When Brecht finally arrived after a harrowing journey across Russia, sailing from Vladivostok to the port of San Pedro, what unnerved him most about Los Angeles was its pleasantness. With Europe and Russia plunged into hell, how could Santa Monica be so sunny? It seemed indecent, utterly wrong.

To create the screenplay for *Two Marxists in Hollywood* I restructured Eisenstein and Brecht writing during their time in Hollywood into an interview format. I hired young actors to portray Eisenstein and Brecht and filmed at Los Angeles locations important to each of them. To visually represent the disjunction in time, the young actors stood in front of painted backdrops depicting the location as it appeared in the 1930s and '40s. Between the interviews, tracking shots and aerial views map the city across its socioeconomic divides: from the mansions built for the movie moguls to working-class houses to the oil wells, warehouses, shipping port, and film studios. Both Eisenstein in his notes for *Glass House* and Brecht's in *A Model Family* connect architecture to economic structure. Thus I felt that it was important to foreground how the landscape of contemporary Los Angeles can be read as through this lens, revealing not only the wealth inequalities but also the flow of commodities, both goods and entertainment.

Pages 13–15: Bertolt Brecht, journal entries, August 1, 1941, January 9 and January 14, 1942. Photograph page 15, bottom, by Ruth Berlau.

1.8.41
fast an keinem ort war mir das leben schwerer als hier in diesem schauhaus
des easy going. das haus ist zu hübsch, mein beruf ist hier goldgräbertum,
die glückspilze waschen sich aus dem schlamm faustgrosse goldklumpen, von
denen dann lange die rede ist, wenn ich gehe, gehe ich auf wolken wie ein
rückenmärkler. und gerade hier fehlt grete. es ist als hätte man mir den
führer weggenommen gerade beim eintritt in die wüste.

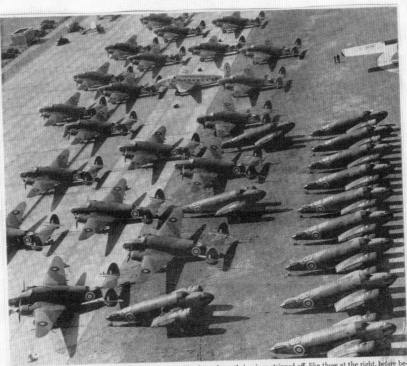

Lockheed bombers destined for the R. A. F. mass at Floyd Bennett Field in Brooklyn. Flown from the hard-working California factory (*see previous page*), these Hudson bombers will have their wings stripped off, like those at the right, before being shipped. Hudsons are dependable planes, greatly admired by the British. They are being built at the rate of four a day.

Selections from Brecht's journals, translated by Hugh Rorrison

1.8.41 (page 13)
almost nowhere has my life ever been harder than here in this mausoleum of *easy going*. the house is too pretty, and here my profession is gold-digging, the lucky ones pan big nuggets the size of your fist out of the mud and people talk about them for a while; when i walk, i walk on clouds like a polio victim. and i miss grete, here especially. it is as if they had taken away my guide as soon as i entered the desert.

9.1.42 (page 15)
write to HITLER'S SOLDIERS IN RUSSIA after much talk about sending material to moscow radio.

14.1.42 (page 15)
read louis fischer's SOVIETS IN WORLD AFFAIRS with interest. the russian question actually dominated the whole paris peace conference. interesting how the allied armies proved unfit to fight the soviets. Photo: "In [Peter] Lorre's first house." [Brecht (center) with Peter Lorre (below, only top of head visible) and Max Gorelik (right)]

16.1.42
directors and actors here want stories with a "message," ie a moral, a metro-goldwyn-mayer gospel for the little man. take bergner; she has in mind something like this: a girl is hypnotized, runs off in a trance, does something in a trance, but is actually not in a trance, just pretending etc, and this is supposed to contain a message. difficult.

21.1.42
odd, i can't breathe in this climate. the air is totally odorless, morning and evening, in both house and garden. there are no seasons here. it has been part of my morning routine to lean out of the window and breathe in fresh air; i have cut this out of my routine here. there is neither smoke nor the smell of grass to be had. the plants seem to me like the twigs we used to plant in the sand as children. after ten minutes their leaves were dangling limply. you keep wondering if they might cut off the water, even here, and what then? occasionally, especially in the car going to beverley hills, i get something like a whiff of landscape, which "really" seems attractive; gentle lines of hills, lemon thickets, a californian oak, even one or other of the filling-stations can actually be rather amusing; but all this lies behind plate glass, and i involuntarily look at each hill or lemon tree for a little price tag. you look for these price tags on people too. — not being happy in my surroundings is not something i like, especially in these circumstances. i set great store by my status, the distinguished status of refugee, and it is quite unseemly to be so servile and keen to please refugees as the surroundings here are. but it is probably just the conditions of work that are making me impatient. custom here requires that you try to "sell" everything, from a shrug of the shoulders to an idea, ie you have always to be on the look-out for a customer, so you are constantly either a buyer or a seller, you sell your piss, as it were, to the urinal. opportunism is regarded as the greatest virtue, politeness becomes cowardice.

9.1.42
schrieb AN DIE HITLERSOLDATEN IN RUSSLAND, nachdem viel über eine belieferung des moskauer radios gesprochen wurde.

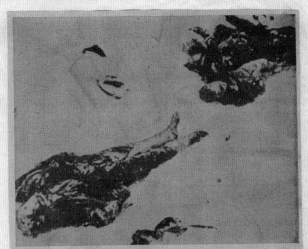

General Winter has scored on the bodies of German soldiers, shown in this picture in a snow-covered ditch on the Moscow front. Cablephoto was sent from London. *Photo by Wide World*

14.1.42
lese mit interesse Louis Fischers SOVIETS IN WORLD AFFAIRS. die russische frage beherrschte tatsächlich die ganze pariser friedenskonferenz. interessant, wie die fnteralliierten armeen sich als untauglich zur bekämpfung der sovjets erwiessen!

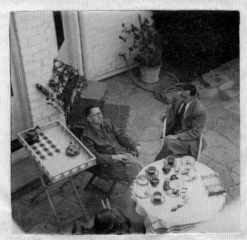

in Locus coban hun. Gorobis. Evre.

COMRADES AND COLLABORATORS

I could describe myself as one of Eisenstein's second-generation students. Stefan Sharff, the professor at Columbia University who taught me everything I know about film, worked with Eisenstein in the 1940s in the Soviet Union. I embraced Eisenstein's Russian formalist approach to cinema: film as a visual language with its own grammatical rules. But as a student I thought of Eisenstein as a figure from another epoch, a master embalmed by history whose films with crowd scenes and battleships had nothing to do with my life.

Many years later, I no longer think it is helpful to look up to great artists; indeed, there is nothing more stultifying than being a disciple. Instead I would like to invite them to be our collaborators across time. This means representing people from the past, but not by creating an illusion of presence as in the conventional costume drama where a historical figure appears as a fully formed replica. Instead I want to show them more simply and honestly as constructions we create with the evidence we have.

And so in *Two Marxists in Hollywood*, Eisenstein and Brecht are played by twelve- and thirteen-year-old boys. To me they best embody the enthusiasm and the naïveté of these artists who set out, against all odds, to challenge the formulas of the motion picture industry. Children look toward the future. They are learning, in the same spirit that I think all artists should think of themselves as researchers who are finding out about the world. Also, I felt that if I couldn't explain something about Eisenstein's and Brecht's ideas to twelve-year-olds then there was something wrong. My job as an artist and director is to make difficult ideas clear to everyone. I think this might have been easier to accomplish with Brecht. Brecht wrote in such a straightforward way, just as though he was talking to you. Ben Taylor, who played Brecht, learned that as a Brechtian actor his job was not to "be" Brecht but to represent him to us as clearly as he could. Along the way, he learned something about socialism and why bankers are swindlers. Because Charlie Chaplin's work was enormously inspiring to both Eisenstein and Brecht, I asked the young actors to watch Chaplin's film *The Gold Rush*. They were quite shocked that a movie so old was so funny.

In my film version of *A Model Family*, Brecht is played by a ventriloquist doll, "Little Bertie."[5] In *Glass House* Eisenstein's head is a cardboard box. Not only are these figures obviously constructions but they are also playful and irreverent if not downright absurd. This too is important.

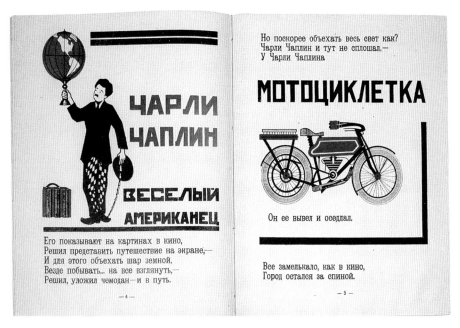

The Travels of Charlie by Nikolai Smirnov with illustrations by Olga and Galina Chichagova, 1925.

THE REVOLUTIONARY POTENTIAL OF LAUGHTER

Today we don't seem to talk enough about humor in relation to art. Walter Benjamin celebrated the revolutionary potential of laughter. He saw the joke as a moment of liberation in which cracks and fissures abruptly opened up the status quo, producing in its own way what surrealists might call a disorientation of the senses, a glimpse of freedom on both a psychic and a political level. In a short essay on Charlie Chaplin, Benjamin wrote, "In his films Chaplin appeals both to the most international and the most revolutionary emotion of the masses: their laughter."[6]

I discovered a photograph of Eisenstein with three Felix the Cat dolls in the archives in Moscow. I think he won them on the Venice pier where Chaplin would take him for an evening's entertainment. I had never seen this picture before because I think it shows a side of him that history has repressed.

Eisenstein and his friends were welcome guests in Chaplin's mansion in the Hollywood Hills. He would entertain them by practicing gags for his film *City Lights* on his lawn. Picture the first scene of the movie, the dedication of a civic statue. The tarp is removed and all of a sudden the Little Tramp

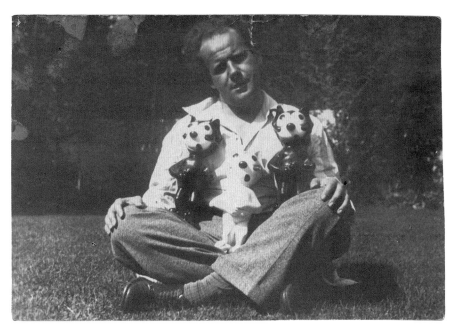

Eisenstein with three statues of Felix the Cat, Hollywood, 1930.

is unveiled sleeping soundly on the statue's lap, consternation among the dignitaries. The tramp is embarrassed. His pants get caught on the statue's sword. He can't get down. It's hilarious. And through laughter something is revealed. The homeless person is exactly this, a victim of the Depression that the wealthy are trying to hide by erecting a grotesque marble monument. Chaplin shows us how the world works, not with anger but with wit. Suddenly we see how phony this civic pride really is. There is money for marble statues but not enough to put a roof over someone's head. It is not surprising that Brecht thought Chaplin would be the perfect actor for his epic theater.[7]

In his notes for *Glass House* Eisenstein imagined a whole new form of intellectual montage based on laughter. He wrote that the film would call into question the spatial and social relations between objects and people. He anticipated the salvo of laughs that would accompany the spectators' sudden, unexpected insight. He believed that the economy of expression and comprehension in intellectual cinema was analogous to the psychical economy of wit Freud describes in his 1905 study *Jokes and their Relation to the Unconscious*. In his notes for another unrealized project, *Capital,*

Eisenstein imagined a film on Marx's theory of economics, incorporating the grotesque and the farcical. It would even involve a puppet theater.[8] Why not?

Today we don't often associate Brecht or Eisenstein with laughter. But when we look back to the 1920s and '30s we can glimpse a very special moment when the radical and the popular came together in all kinds of new ways. In the Soviet Union El Lissitzky and Mayakovsky were creating books for children. Walter Benjamin was broadcasting on Berlin Radio's *Youth Hour*. And Chaplin's Little Tramp, a homeless man, a man without a home, took the world by storm and found a home everywhere.

I suggest that bringing Brecht's and Eisenstein's dialogue with popular culture to the fore is a political project. Working in theater in the 1920s, they were both inspired by the circus, vaudeville, and even sporting events. These forms of popular entertainment, with short scenes based around physical actions, inspired both Brecht and Eisenstein to bring radically different elements into collision, to create what Eisenstein called a "montage of attractions." Each wanted to overthrow the overstuffed bourgeoisie drama with its sentimental characters. Brecht was fascinated by the way audiences reacted at boxing matches or burlesque shows. He loved the way they yelled at the performers and argued with one another rather than sitting in polite silence.

Unlike many artists today Eisenstein and Brecht were not simply raiding popular forms for the next cool idiom to entertain art world connoisseurs. When they incorporated popular culture into their own work, it was not to wrest it away from its roots but to make it more interesting and thought provoking. This is one reason why their time in Hollywood is significant. Cinema is a medium that was accessible and affordable to almost everyone. Both of the scenarios I have chosen to reconstruct are humorous. Eisenstein subtitled *Glass House*, "a comedy for and about the eye." *A Model Family* is about a family's misadventures at the state fair, and one can picture it as a comedy where everything goes wrong!

TRUST THE PEOPLE
While the studio executives talked about "catering to an audience," that is, dumbing things down to the lowest common denominator, Eisenstein and Brecht wanted to do something much harder. They aimed to engage their audience but also invite them to think. They wanted to make radical art for ordinary people. This is central for me as an artist to put forward this very

simple idea that entertainment and critical thinking do not contradict but rather complement each other. Brecht put it clearly when he wrote that one must not assume what ordinary people like and want, one must not second guess their taste. It is these kinds of assumptions that keep working people oppressed in the first place.

Brecht was excited about learning from art forms that come from popular culture of his time such as cabaret and jazz. In my films I wanted to connect past and present because I too am inspired by what one might call the vernacular avant-garde. In *Two Marxists in Hollywood*, I juxtaposed the modernist music of Hanns Eisler, Brecht's close friend and collaborator, with the sound of contemporary Los Angeles rappers. The style of my large drawings in the exhibition is inspired by Soviet children's books from the 1920s, the watercolors of the British war artist Eric Ravilious from the early '40s, and contemporary graphic novels.

At the heart of Eisenstein's and Brecht's desire to make works for a popular audience is an understanding that all of us are thinking individuals. Brecht made this very clear in his writing on two concepts that were central to his practice: popularity and realism. He was very specific about his concept of realism. He wrote, "Realistic means: discovering the causal complexes of society / unmasking the prevailing view of things as the view of those who are in power / writing from the standpoint of the class which offers the broadest solutions for the pressing difficulties in which human society is caught up / emphasizing the element of development / making possible the concrete and making possible abstraction from it."[9] To put it very simply art should help us understand how our society is structured, not by the forces of nature but by human motivation and action. It is this that will help us understand that things don't have to be as they are.

He believed there wasn't one right way of doing this: "With people struggling and changing reality before our eyes, we must not cling to 'tried' rules of narrative, venerable literary models, eternal aesthetic laws. We must not derive realism as such from particular existing works, but we shall use every means, old and new, tried and untried, derived from art and derived from other sources, to render reality in a form they can master...we shall allow the artist to employ his fantasy, his originality, his humor, his invention in following them."[10]

Indeed one must remember that although Eisenstein and Brecht had broadly the same cultural ambitions, their approaches were different.

Eisenstein wanted to influence the spectator directly and forcefully while Brecht aimed to make his audience think about the situations he depicted, rationally and impartially. Eisenstein considered Brecht's plays too cold and analytical. However, Brecht greatly admired Eisenstein's films, which had, according to a journal entry in 1938, a "colossal effect" on him. "What an eye the man has!" he declared on seeing Eisenstein's Mexican footage.[11] Nonetheless he was concerned that Eisenstein's films were too manipulative, depriving audiences of the necessary distance to think for themselves.

The only one of Brecht's screenplays produced in Hollywood, *Hangmen Also Die*, was about the Czech resistance. He wanted to call it *Trust the People*. And I think he meant just that. He described an audience as "a collection of people with a desire to improve the world listening to a report about the world" and that the play or film should "unleash everybody's creativity."[12] He trusted the working class, even though the German working class disappointed him with a barbarism that today we can barely grasp. I think this trust has gone out of style.

Since Brecht and Eisenstein's time in Hollywood, the cinema I would argue has only congealed and hardened—the blockbuster, the independent feature, the so-called avant-garde film domesticated and codified by the degree-granting programs of liberal arts colleges. Of course there are filmmakers who have been inspired by aspects of their project. There are the brilliant essay films of Harun Farocki and now Hito Steyerl; there are the Brechtian films of Straub and Huillet. But these are works by and for intellectuals. They are not for everyone.

GLASS HOUSE

Eisenstein first had the idea for *Glass House* in 1926 when visiting Fritz Lang under the glass dome on the set of Lang's film *Metropolis*. He was fascinated by the new modernist glass architecture of Bruno Taut and Ludwig Mies van der Rohe. He discussed his ideas with Le Corbusier. But unlike Taut and architects of the Glass Chain who imagined that the transparency of glass would free people from the old hierarchies, Eisenstein pictured the horror of a world of total surveillance that would come into being not only in Stalin's Soviet Union but during the cold war and now in global surveillance partnerships between government agencies and major corporations.

In 1930, with a six-month contract at Paramount Studios and more or less carte blanche to develop whatever project he wanted, Eisenstein

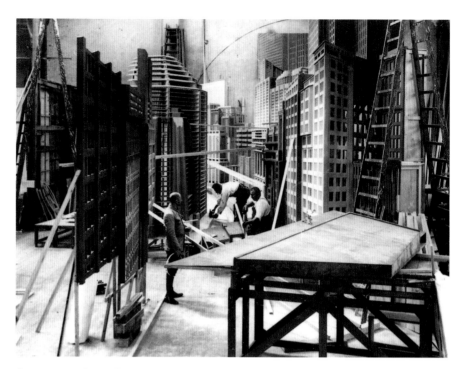

Constructing the set for the film *Metropolis* directed by Fritz Lang, 1926.

worked on *Glass House*. He imagined the opening of the film as pure abstraction, writing, "Prologue—a symphony in glass (no objective). All forms. Glass Hair and threads reach out...floating effects of heavy objects—light obliterates glass and makes only solid objects visible...People do not see. Only the camera sees. Rotation in space. Weightlessness."[13] This fantastic structure was very much in keeping with other visionary proposals by Soviet architects and engineers of the period. Georgy Krutikov's drawings for *The Flying City* (1928) depicted living spaces housed in communes in the sky. Konstantin Tsiolkovsky imagined orbiting even higher in the stratosphere, with human colonies in the cosmos.

In the first act, Eisenstein wanted to show that the inhabitants of the glass house are unaware of one another. They do not see their neighbors because they do not look; the wealthy are willfully oblivious to their impoverished neighbors. Three characters emerge: the Architect, who constructs the house; the Poet, an idealist; and the Robot, a personification

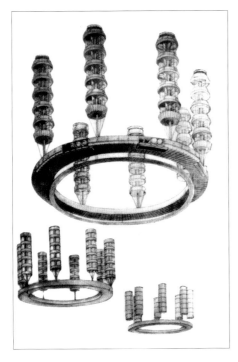

Georgy Krutikov, drawing for *The Flying City*, 1928 (left), and Konstantin Tsiolkovsky, drawing of a space vehicle for *Free Space*, 1883 (right).

of the new man. When the Poet opens people's eyes it leads to violence, hatred, and catastrophe. The Poet hangs himself and the Robot, unable to deal with the contradictions, destroys the house.

The studio tried to find a screenwriter to flesh out this scenario but none of them grasped what Eisenstein was driving at. Their approach was whimsical while he imagined something hard-boiled. The only person who understood his vision was Chaplin. He urged Eisenstein to persevere. And indeed when Eisenstein reached a mental block, Chaplin suggested he consult his psychoanalyst, Dr. Reynolds.[14] With the help of high-speed analysis Eisenstein rapidly reconfigured the Architect, Poet, and Robot into an oedipal drama.

But I believe the problem was more fundamental than the shape of the plot. Eisenstein didn't care about conventional story structure. In fact at one point he simply scribbled "plots, plots, plots." As far as he was concerned, any plot would do, the more the better. Here is just one of his many lists:

Suggestions for the story

1. Swimming pool as a ceiling. Romance beginning in the pool. Noticing it from below.
2. Suicide in closed room. All walls—faces. Cubus of human beings in the air when fight for rope.
3. Love scenes in pajamas in the snow storm.
4. Drunkard in corridor.
5. Lion in the corridor. Children sneer at him.
6. The artificial man (Robot) His human rôle (the only human being) using his mechanical movements as humanly expressif ones.
 The machinery goes wrong.
 The man sent to make love to important woman.
 His role in ~~braking~~ destroying the house.
7. The dying woman (starving) and the lifts (food-lifts).
8. The lover under the bed.
9. The speak-easy.
10. A man beats his wife.
11. The Glass prison (one cell or a series of cells).[15]

Sergei Eisenstein, notes for the film *Glass House*, 1930.

Suggestions
for the story.

1. Swimming fool as a ceiling.
 Romance beginning in fool. Noticing it
 from below. [NB. Seconding scene?]

2. Suicide in closed room. All walls - faces.
 Cubus of human beings in the air when
 fight for rope.

3. Love scene in pyjamas in the snow storm

4. Drunkard in corridor.

5. Lion in corridor and children near him.

6. The artificial man. [Robot]
 his human rôle [the only human being]
 using his mechanical movements as
 humanly expressif ones.
 The machinery goes wrong.
 The man sent to make love to unfortant
woman.
 His rôle in breaking destroying the house

7. The dying woman [starving] and the lifts
 [food lifts]

8. The lover under the bed.

Eisenstein was endlessly inventive. He imagined the extraordinary optical effects of glass apartments filled with smoke or with water. He imagined a war breaking out between the tailor faction and the nudist association. He wrote, "The nudist chief succumbs with the tailor's daughter, rampage of the moral police. The Robot is sent to rape important women."[16] His film would have been nothing less than a violent sex comedy. For me, his notes are an invitation to create a form of cinema that simply does not yet exist, that belongs to no known genre. Eisenstein wanted to make films that were both essays—intellectual cinema—and narrative, with actors, which would also be extraordinary visual works of art.

While I leave it to the historian to study Eisenstein's completed works, these sketches are by their very nature open ended and forward looking. There could be many *Glass House* films, each made by a different filmmaker. I think of my *Glass House* as part documentary on Eisenstein and part imaginative riff from a contemporary perspective.

For me, the very impossibility of materializing what was to have been a million-dollar movie is part of the excitement and challenge. I believe strongly in doing what one needs to do as an artist with whatever one can lay one's hands on. The paucity of resources, the fragmentary nature of his scenarios, forces me to dream and to speculate, not to illustrate.

Instead of a conventional drama, Eisenstein wanted to construct an essay as artwork that would bring together dialectically the rational and the irrational, the conceptual and the sensuous in an architectural critique of modern life. Here lies the importance of his drawings. Beyond simply storyboard sketches, they are the excess, the dream work that could never find a place in the cultural sphere in either East or West. Drawings like the "nudiste association" fantastic women who flaunt eyeglasses over their breasts and thus make spectacles of themselves exist in a limbo, between categories, too funny to align with Picasso and too sexy to belong in Disney's animated universe.

I use animation to make visible the dialogue between drawing and filmmaking that always remained latent in Eisenstein's work. My version of *Glass House* opens with Eisenstein's journey to America. The cardboard cutouts of a train, boat, and plane that move across a giant map from Moscow to Los Angeles are inspired by the Soviet animated film *Pochta*

The robot Herbert Televox, designed by Roy Wensley for Westinghouse in 1927. It could accept a telephone call by lifting the telephone receiver and utter a few primordial buzzes and grunts. The photograph was given in 1930 by the supervisor of research at Paramount Pictures to Eisenstein while he was developing his film *Glass House*.

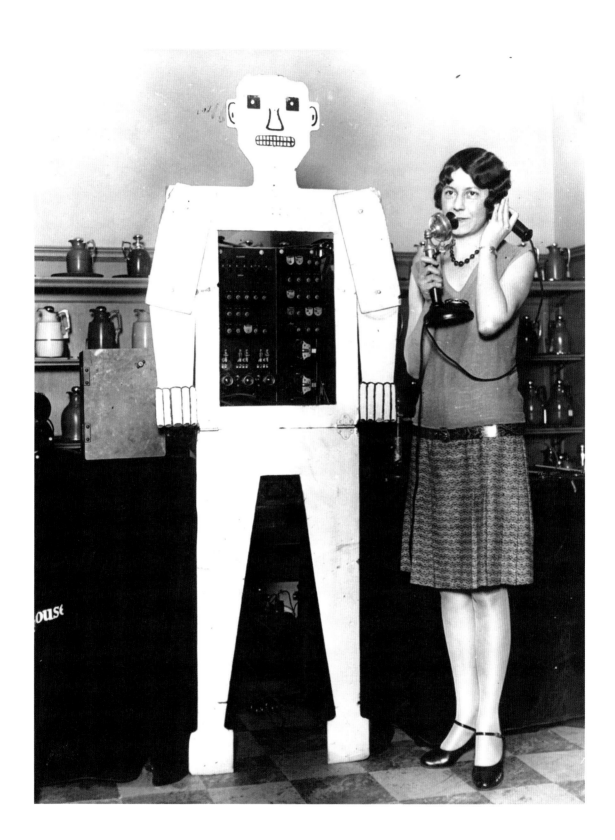

(1929). Once Eisenstein arrives in Hollywood he falls under the spell of Mickey Mouse.

Eisenstein was fascinated by Disney's animation as a kind of primal form of expression, the ability of shapes to morph before our eyes suggesting the possibility of a world redrawn. He wrote, "To be in a country, in a social structure that is particularly merciless in the standardization and mechanization of its daily life—which is difficult even to call a life—and then behold such 'omni-potentiality,' i.e. the ability to become 'whatever you want' can't but carry a measure of piercing attractiveness. This is very true of the USA."[17]

Through drawing, Eisenstein imagined a world where radical social transformation unleashed the unconscious. In his private sketches he conjured a universe of pan sexuality and homoeroticism that he was only able to glimpse briefly in his life. I was particularly intrigued by his many drawings for the *Glass House* revue. I imagine these creatures inspired by his forays into the gay nightclubs of Berlin, including the famous Eldorado, where he spent time en route to the United States. He said of himself that "Had it not been for Leonardo da Vinci, Marx, Lenin, Freud and the movies, I would in all probability have been another Oscar Wilde."[18] But he never completely sublimated his desires.

Although Eisenstein is often considered a model of the severe communist director, there is always another Eisenstein who loved to traffic in the bizarre and the fantastic. From the clown with a light bulb brassiere in his version of the play *Enough Stupidity in Every Wise Man* who prefigures the little men strapped to the singer in the *Glass House* revue to the orgiastic dance by the Oprichniki in *Ivan the Terrible, Part II* centered on a young man dressed as a woman, ambiguous sexual motifs are integral to the fabric of his creation.

In addition to Eisenstein's writing on animation, I was inspired in the construction of my *Glass House* by his two great theoretical proposals on the formal properties of cinema, the first on the relationship between sound and image and the second on the shape of the cinema screen, its aspect ratio, both of which fell on deaf ears. In 1928 at the very inception of the sound era he wrote that sound should not be used for cheap emotional effect but should be constructed contrapuntally—to create new meanings in relation to the image. The proper place of the voice was not dialogue but monologue, that of inner language, stream of consciousness, thinking aloud.

Mickey Mouse greets Sergei Eisenstein and Walt Disney at the Disney Studios, 1930.

In 1930 Eisenstein spoke at the Academy of Motion Picture Arts and Sciences against the plans under way for wide-screen film. He declared, "It is my desire to intone the hymn of the male, the strong, the virile, the vertical composition" before finally suggesting a dynamic square.[19] Thus my *Glass House* has a contrapuntal soundtrack and a vertical aspect ratio.

Working on his plans for *Glass House* Eisenstein envisaged a new kind of montage through the medium of transparent glass walls and floors, that is, montage within the frame. Rather than meaning arising from the collision of one shot with the next, new ideas could erupt within a single shot as multiple conflicting tableaux could be seen simultaneously through the transparent walls of a single room. Eisenstein wrote that this film would defamiliarize our world and enable us to see it in new ways.

I conceptualize *Glass House* as a house of cinema, a multiplex. At the same time Eisenstein was sketching out his ideas other members of the avant-garde in the USSR, such as Boris Arvatov, declared that the essence of bourgeois cinema resided not just in films but in the conventional architecture

of the movie theaters themselves structured as they are around a passive audience. Eisenstein's notes for *Glass House* propose that the real spectacle is life itself. Here the inhabitants are both actors and performers. They spy on their neighbors through glass walls, ceilings, and floors just as though they were watching films from extraordinary new angles.

Eisenstein did not actually shoot any footage so I began with a strategy suggested by the great film essayist of dream Raul Ruiz. In his *Poetics of Cinema 2*, from 2007, Ruiz wrote that within every film lies other as yet unknown films traveling like contraband hidden inside them, and that if these fragments can be reassembled other films will begin to emerge.[20] This is Eisenstein's method of montage, from the perspective of the other side, the unconscious. My *Glass House* is inhabited by characters from films by directors that Eisenstein admired. They break out of their original context connecting to each other in new ways. Liberated by montage within the frame, projected onto the walls of my *Glass House,* the robot from the Disney cartoon *Mickey's Mechanical Man* becomes a lascivious voyeur and the Little Tramp from Chaplin's *The Circus* finds himself trapped in the funhouse that is the *Glass House*.

Of course Eisenstein was planning a very expensive studio film. In contrast my budget was almost comically modest. I took my cue from his early work in theater where his budgets were limited and his cast small. His plays were highly stylized with striking, visually graphic costumes. I was inspired by his first film, the five-minute *Glumov's Diary*, which he shot in one day and incorporated into the play *Enough Stupidity in Every Wise Man*. Thus my *Glass House* illuminates another Eisenstein, parallel to the one embalmed through *Battleship Potemkin* with its location shooting and crowd scenes, traversing a trajectory from constructivist theater to animation.

Eisenstein wanted to show us the architecture of total surveillance predicated on the regime of the visible. At the end of his notes for *Glass House*, the Robot destroys the house and, I believe, brings to an end this regime of optical knowledge. If Eisenstein had lived another ten years he would have witnessed the launch of Sputnik, the first man-made satellite, which in turn inspired the invention of the Global Positioning System. To show this transition to surveillance beyond that of the eye, I end my *Glass House* with the sound of Sputnik accompanying the Robot's transformation

Sergei Eisenstein, drawing of Mickey Mouse and Herbert Marshall, Eisenstein's first English-speaking student and later the translator of his work. According to Ivor Montagu, when Eisenstein first encountered Marshall in London, he thought very highly of him as a comic actor—a talent that Marshall later successfully concealed.

into a digital signal. From the vantage point of our century we can picture Eisenstein's Robot as the precursor to the computer and to the wireless technology that gave birth to an era where we are tracked by data, by GPS coordinates, our image composed of the websites we visit, the cell phone towers around us, and the purchases we make.

A MODEL FAMILY IN A MODEL HOME

All that we know about Bertolt Brecht's plans for the film *A Model Family* comes from a few typed notes and some scrawled notebook entries in 1941. The article in *Life* magazine from which he took the title and the premise was a report on the residency of the Frank Engles family in a model home at the state fair. The Engleses hailed from Berlin, Ohio, and were the proud winners of a competition for "Ohio's most typical farm family," sponsored by the local newspaper the *Columbus Dispatch*.

Life's reporter described the scene at the state fair in this way: "The little white house in which they dwelt was equipped with every modern convenience. It lacked however, one traditional and highly important element of home life. It lacked privacy. From 10 in the morning till 10 at night the Engels attended to their chores, ate their meals and entertained themselves beneath the curious and amused scrutiny of thousands of strange eyes."[21] Brecht imagined what might have been the result: family quarrels, smashed furniture, and a divorce.

Like *Glass House, A Model Family* is in part about the nightmare of visibility. Brecht was well aware that as an "enemy alien" he himself was being monitored by the FBI. However, I do not think that surveillance was central to his interest in this story.[22] Although I am sure he understood that the Engles family was performing its life on a stage for a paying audience, I do not think he was interested in using the story to make a statement on the prurient interests of the public or the exhibitionism of ordinary people. Quite the contrary, Brecht did not want to sensationalize working people or turn them into objects of ridicule. If he imagined that the family destroyed everything, including themselves as a family, it was for a different reason. And to understand this I would have to learn more.

Here is what I do know. Brecht's approach was down to earth. He wanted to invite his audience to think about the situations he depicted, calmly and objectively. He wanted to re-present everyday life to us in such a way that we could understand how economic forces shape our lives. He read *Life* avidly not only to improve his English but also to understand how people live

in this country and the things that interest them. He thought that a newspaper report was the best model for dialogue and dramatic action. But that didn't mean the film should be dry or dull. Like Eisenstein he believed in creating a montage of disparate elements so that the audience could look at a subject from different points of view. His cowriter on *Hangmen Also Die* John Wexley recalled that Brecht wanted to incorporate documentary film clips, posters, and songs into his Hollywood films.

Ultimately I spent more time than Brecht researching the model home. And only after discovering more about the actual events at the Ohio State Fair did his notes begin to make sense to me. Alfred Eisenstaedt, staff photographer for *Life,* took almost a hundred photographs of the event. Brecht saw only the ones that were published in the magazine. I was able to review all the outtakes as well. I read articles and advertisements published in the *Columbus Dispatch*, the newspaper that sponsored the competition.

"A Model Family in a Model Home" was a marketing ploy. The *Columbus Dispatch* ran lengthy articles about all of the companies that built and furnished the home. Everything in the house had a large price tag affixed to it. The lamps were still wrapped in cellophane. A lady in a white coat, the "home economist," demonstrated the latest kitchen appliances to Mrs. Engles and the passing multitudes. The photographs made concrete something that Brecht had already observed about life in Los Angeles; he wrote, "The landscape here lies behind plate glass and involuntarily I look for a little price tag on this chain of hills or that lemon tree. You also look for the little price tag on people."[23]

The competition held out the promise that "Ohio's most typical farm family" would be honored at the state fair. Instead they were simply used as living advertisements. Their job was to move the merchandise. It was hard unpaid labor. The intimacy of family life was just one more commodity that was on view. I imagine Brecht wanted to show that it was against this alienation that the family rebelled, destroying not only the model home but themselves as a model family. They simply refused to be exploited. In my film I show how excited he is by their outburst, smashing pots and pans and tearing off their award ribbons, because he respected working people and believed that against all odds they had the courage to challenge injustice.

I wanted to celebrate the American farm family and explore Brecht's ideas about the home as a stage upon which larger political and social forces are played out. I think of my film as an essay that is both a documentary and a critique of documentary practice. In historical documentaries archival

footage is normally used to illustrate the narration, to guarantee its veracity. In contrast I use archival footage not as "evidence" but rather as different perspectives or lenses through which we can picture the world. In the spirit of a film that celebrates everyday life, I decided to work with the vernacular format of the twentieth century, 16mm, and incorporate home movies, newsreels, and instructional and promotional films so that *A Model Family in a Model Home* is itself a "home movie" about a home.

But in my film home movies of sunny Los Angeles are torn through by shards of a World War II newsreel, a reminder that while the Engles family captivated the readers of *Life* war raged across Europe and Leningrad was under siege. Gradually it becomes clear that the heightened promotion around the state fair was part of a collective psychic drive to block out, at all cost, the horror engulfing the rest of the world. Again I took my cue from Brecht. Even when he did not write about the war, his journals were full of photographs of the conflict overseas ripped from the newspapers.

The core of my film, the conflict introduced by the events at the state fair, revolves around the economics of home ownership. Brecht left the country in 1947 at the very inception of the postwar housing boom. One could say that the marketing of mass-produced suburban homes to ordinary Americans began with competitions like the one that staged the event "A Model Family in a Model Home."

My film presents the economic choices that faced rural Americans at the time when Brecht was writing this work. They could have chosen a socialist model of home ownership represented by the film *By the People, For the People* produced by the National Rural Electric Cooperative Association. Here the farmers themselves own property together. They collaborate and share the profits. Or they could have chosen the capitalist model represented by the film *Homes Unlimited: A Tale of Free American Enterprise* produced by the National Homes Corporation, a company that built prefabricated houses. This model of home ownership by the individual family primarily benefits developers and the banks. I present these two films not as historical facts but as potentials that likely would have led in different directions.

The final section of my film, titled "Fictitious Capital," brings us to 2015. The landscape of the rural Midwest has changed. Giant malls with big box stores have replaced local merchants that furnished the model home in 1941. The city sprawls into the country, the farm home has been eaten up by the subdivision.

The housing crisis of 2008 was caused by uncontrolled speculation that led to massive foreclosures. We see the results. They are technically known as

Advertisement in the *Columbus Dispatch*, August 24, 1941.

---BUT THE SUN ALWAYS SHINES IN OHIO

"zombie subdivisions." Not subdivisions taken over by flesh-eating zombies but subdivisions that were foreclosed on or never finished, where forlorn streetlamps stand beside unfinished streets and grass grows up through the cracks. The film ends with a song, "Supply and Demand," with music by Hanns Eisler, from Brecht's play *The Measures Taken*, rewritten for today. It is sung not by a merchant but by a banker because today it is the bankers who control supply and demand in the housing market. They lend money to the developers to build the homes and they give mortgages to people who want to live in them. And if they decide to change the terms and foreclose the homes, they still make their money on fees, they still collect their bonuses. The banks are accountable to no one.

By sketching out different forms of ownership the film suggests that the housing collapse in which six million people lost their homes was not natural or inevitable. And if the present system of finance is not working, ordinary people might do well to decide, like Brecht's model family, that they have had enough.

When Brecht and Eisenstein wrote, they would have had no idea where the scenarios they imagined might lead. This is true for all artists. When one creates something, one starts a dialogue with people in the world, even if one does not yet know when or with whom one might find a response. I believe that to begin conceptualizing new ways of thinking about our social world, one must start to draw new time lines, setting in motion new trajectories between past and future. It is here that the archive becomes not a repository of dead things but rather a place to begin new dialogues and make new connections, to help us go forward with our lives today.

Editorial cartoon in the *Columbus Dispatch*, August 23, 1941.

NOTES

1. Sergei Eisenstein, *Film Form: Essays in Film Theory* ed. and trans. Jay Leyda (New York: Harcourt, 1977), p. 106.

2. For more information on the Society, see Zoe Beloff, ed., *The Coney Island Amateur Psychoanalytic Society and Its Circle:* (New York: Christine Burgin, 2009).

3. Quoted in Esther Leslie, *Derelicts: Thought Worms from the Wreckage* (London: Unkant Press, 2014), p. 94.

4. Walter Benjamin, *Selected Writings, Volume 4* (1938–1940) (Cambridge, MA: Belknap Press Harvard, 2006), pp. 391, 396.

5. I discovered after shooting that Brecht got what he asked for. In "Conversations with Brecht" Walter Benjamin noted, "Brecht talks about epic theater, and mentions plays acted by children, which produce alienation effects and impart epic characteristics to the production." From *Aesthetics and Politics* (London and New York: Verso, 2007), p. 94.

6. Benjamin, *Selected Writings*, p. 224.

7. In his note "V-effect of Chaplin" Brecht wrote about his performance in *The Gold Rush*: "Eating the boot (with proper table manners, removing the nail like a chicken bone, the index finger pointing outwards). The film's mechanical aides: Chaplin appears to his starving friend as a chicken. Chaplin destroys his rival at the same time courting him." Marc Silberman, ed., trans., *Brecht on Film and Radio* (London: Methuen, 2000), p. 10.

8. Sergei Eisenstein, "Notes for a Film of *Capital*," trans. Maciej Sliwowski, Jay Leyda, and Annette Michelson, *October*, no. 2 (Summer 1976), p. 7.

9. Bertolt Brecht, "Against Georg Lukács," in *Aesthetics and Politics*, p. 82.

10. Ibid., p. 81.

11. Bertolt Brecht, *Journals 1934–1955*, ed. John Willett, trans. Hugh Rorrison (London: Bloomsbury Methuen Drama, 1993), pp. 4, 365.

12. Ibid., p. 207.

13. Jay Leyda and Zina Voynow, *Eisenstein at Work* (New York: Pantheon, 1982), p. 36.

14. According to Eisenstein's friend Ivor Montagu, Dr. Reynolds was quite an eccentric character: "His cadaverous unwinking earnestness appealed to something mischievous in Charlie, and you may see him for a moment walking on in *City Lights*." Ivor Montagu, *With Eisenstein in Hollywood* (New York: International Publishers, 1974), p. 105.

15. S. M. Eisenstein, *Glass House—Du projet de film au film comme projet* (Dijon, France: les presses du réel, 2009), p. 51.

16. Ibid., p. 48.

17. Oksana Bulgakowa and Dietmar Hochmuth, eds., Dustin Condren, trans., *Sergei Eisenstein: Disney* (San Francisco: Potemkin Press, 2011), p. 15.

18. An interview in the American periodical *New Masses*, quoted in Oksana Bulgakowa, trans. Anne Dwyer, *Sergei Eisenstein: A Biography* (San Francisco: Potemkin Press, 2001), p. 80.

19. Sergei Eisenstein, "The Dinamic Square: Suggestions in Favour of New Proportions for the Cinematographic Screen Advanced in Connection with the Practical Realization of 'Wide Film,'" *Close Up*, vol. viii, no. 1 (March 1931), p. 4.

20. Raul Ruiz, *Poetics of Cinema 2* (Paris: Dis Voir, 2007), pp. 46–47.

21. *Life*, September 15, 1941, p. 42.

22. In his diary entry of 29 May 1942 Brecht notes drily that "in the evening KLINE and his wife and her brother here when 2 FBI men come to look at my registration book, seemingly some kind of check-up to do with the curfew." Brecht, *Journals 1934–1955*, p. 235.

23. Ibid., p. 193.

EISENSTEIN AND BRECHT IN HOLLYWOOD

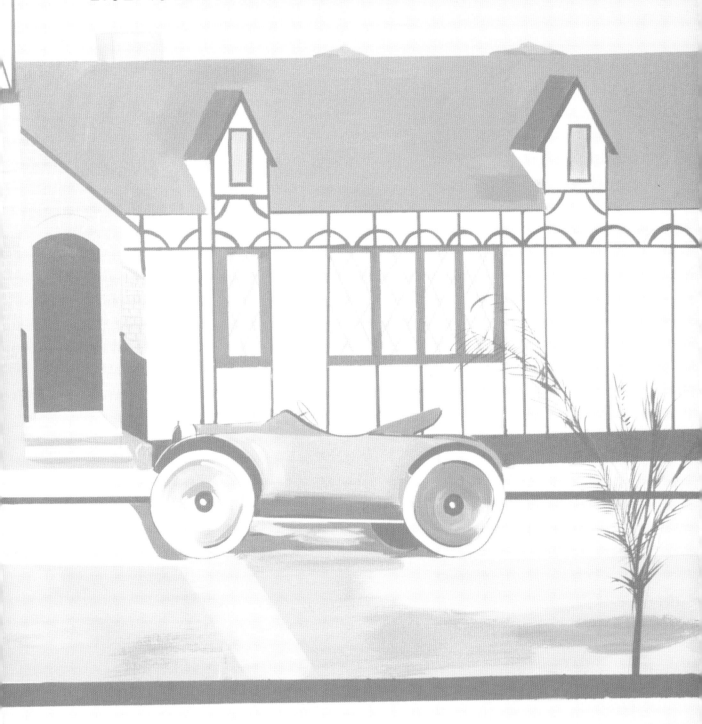

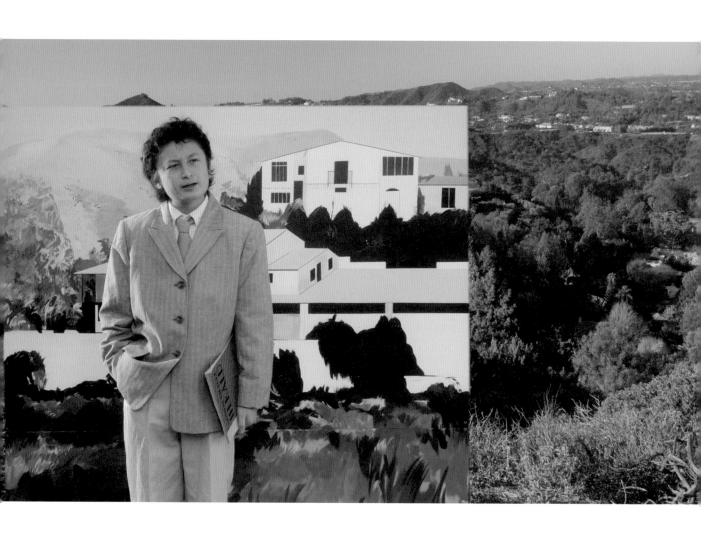

TWO MARXISTS IN HOLLYWOOD

2015

Written and directed by Zoe Beloff, based on texts by
Bertolt Brecht and Sergei Eisenstein
Cinematography by Eric Muzzy
Cast: Bryan Yoshi Brown (Sergei Eisenstein) and Ben Taylor (Bertolt Brecht)
For a complete list of sources, see p. 64
The film can be viewed at http://aworldredrawn.com

EXT. LOS ANGELES AERIAL VIEWS

NARRATOR

In 1930 Sergei Eisenstein spent six months in Los Angeles under contract to
Paramount. Bert Brecht lived here for seven years from 1941 to 1947. Both
set out to make films in Hollywood on their own terms.

Working in the world's most famous factory of dreams, they believed
that artists must call into question the way we understand our world. The
studio rejected all of Eisenstein's screenplays. Brecht was the cowriter of
only one movie that was produced. His name was removed from the credits.
Anticommunist agitation forced both men out of the country.

One might describe theirs as a utopian project that ended in failure. But
what if it was not? What if their ideas were merely lying in wait for us?

EXT. OVERLOOKING COLDWATER CANYON

SERGEI EISENSTEIN

My name is Sergei Mikhailovich Eisenstein. I was born in Riga in 1898.
I died in Moscow in 1948.

I arrived here the twelfth of June 1930. My friend Ivor Montagu found
us this house in Coldwater Canyon. I was most fond of the cook Rosie, half
Negro, quarter Irish, quarter red Indian.

I was ready to make a real American film. Not with stars but with the people and it was the people of California that I set out to study.

Our contract with Paramount provided expenses for six months. They gave a banquet for us at the Ambassador Hotel. The world press was invited. Universal Studios was vying for us.

EXT. LORRAINE BOULEVARD TRACKING SHOT

SERGEI EISENSTEIN (V.O.)
I said to my friends, "The capitalists are beginning to cut each other's throats over me!"

EXT. PARAMOUNT STUDIOS

SERGEI EISENSTEIN
The Americans were very interested in the creativity of Soviet film artists. We wanted to learn the technology of sound. The potential was there for a new kind of sound cinema at the very moment we arrived in Los Angeles.

Imagine listening to your own train of thought, when you catch yourself wondering: What do I see? How? What do I hear?

This would be the basis of the new sound cinema. Not dialogue but monologue. A sound cinema made of images and sounds, sometimes synchronized, sometimes not.

Now suddenly words spoken against a blank screen, a rushing imageless visuality.

Now visual images racing past in complete silence. Now joined by a polyphony of sounds. Now by a polyphony of images. Then both together.

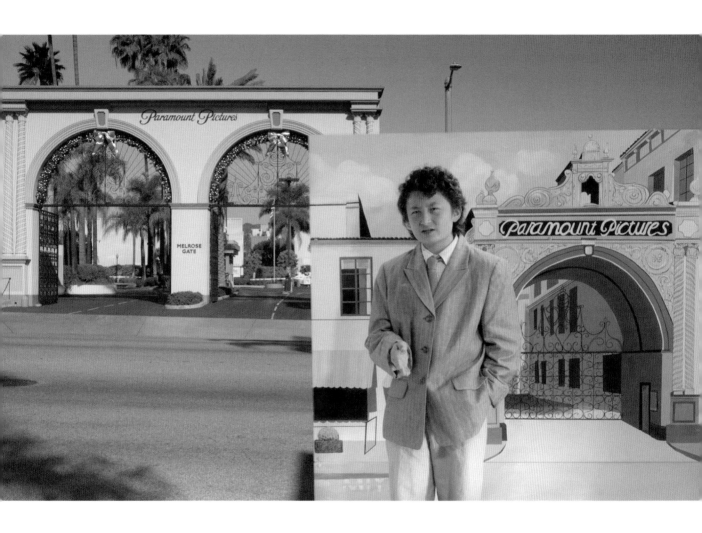

EXT. FOX STUDIOS

NARRATOR

You were asked to speak about the shape of the cinema screen itself, its aspect ratio.

SERGEI EISENSTEIN

Indeed I addressed the technicians branch of the Academy of Motion Picture Arts and Sciences here at Fox Hills Studios at a meeting called to discuss "Wide Film."

 Mr. Chairman, gentlemen of the Academy, I think this actual moment is one of the great historical moments in cinema. It affords us the possibility of reviewing and reanalyzing the whole aesthetic of composition in the cinema.

 I do not desire to be exaggeratedly symbolic, nor rude, when I compare the rectangles on the proposed shapes you provided to the creeping mentality of the film flattened by the weight of the commercial pressure of dollars, pounds, francs, or marks according to the locality in which the cinema must be suffering!

 It is my desire to intone the hymn of the male, the strong, the virile, the active vertical composition!

 They didn't listen. But perhaps tomorrow, who knows, the cinema is changing once more.

AERIAL VIEW: HOMES IN LOS ANGELES

NARRATOR

Today it is easy to make vertical films with our phones. But for Eisenstein, proposing a new shape for the screen is more than just a clever trick. It can be a tool to open up new perspectives. Just as he thinks that separating sound and picture can express new ideas, playful or serious. Was anyone working on this in Hollywood?

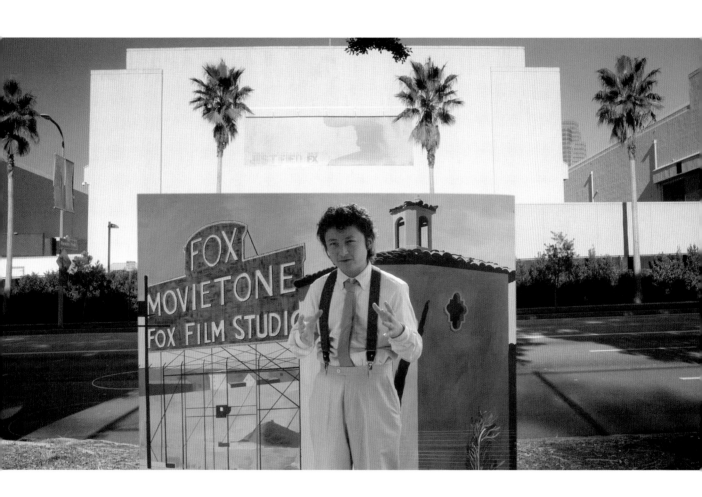

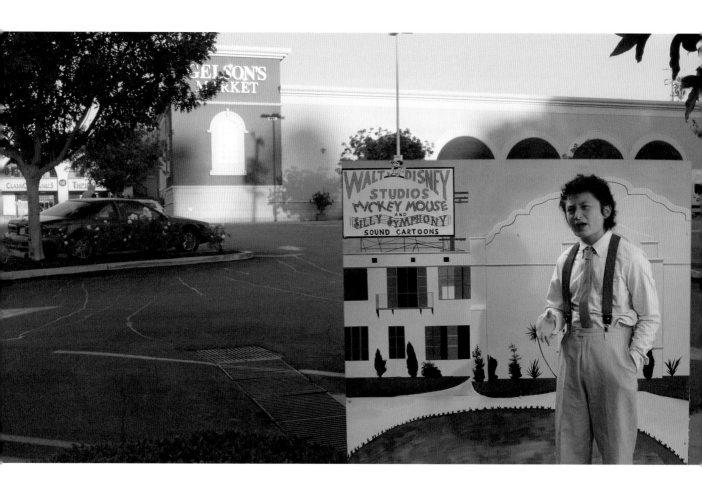

EXT. 2719 HYPERION AVENUE, GELSON'S SUPERMARKET, FORMERLY THE SITE OF THE DISNEY STUDIOS

SERGEI EISENSTEIN

Disney was the only one who understood sound. An ironic synthesis between music and the cartoon.

What do you remember about the precolor Mickey Mouse cartoons? There's a steamboat snacking on logs of firewood as if they were pastries; there are hot dogs who get spanked after having had their skin pulled down in the appropriate place; octopi turn into elephants. A transfigured world, a world gone out of itself. Free once and for all from the prescribed forms of nomenclature, form, and behavior.

A marvelous lullaby for those bound by work hours and the regulated minutes of break time, the mathematical exactitude of the clock, for those whose life is ruled by dollars and cents.

EXT. 2910 GRIFFITH PARK BOULEVARD, SNOW WHITE COTTAGES

This is where the animators lived. Their work was just such a droplet of delight, of momentary relief, a fleeting brush of the lips in that hell of social burdens, injustices, and torment in which American viewers are hopelessly trapped. Yes a moment of oblivion, a complete release from everything connected with suffering created by the conditions of the advanced capitalist state.

I know what you are thinking, it's just distraction for the man on the street...oblivion as a weapon to disarm the struggle.

No, Disney cartoons are quite simply "beyond good and evil." Like sunspots on the surface of the earth they flash, they warm, and they elude the hand's grasp. Yes man, but man, seen as if in reverse in his earliest stages, which were sketched out by Darwin.

EXT. LORRAINE BOULEVARD TRACKING SHOT

SERGEI EISENSTEIN (V.O.)

B. P. Schulberg, Paramount's boss, lived here on this street. I was invited to dinner on several occasions. I tried to explain to him my idea for this film I called "Glass House," a great glass skyscraper in which you could see all around, above, below, sideways, in any direction. I called it a comedy

for and about the eye. I told him that such buildings already exist here in America: banks, offices, newspapers. But it was no use.

EXT. 525 LORRAINE BOULEVARD, FORMERLY B. P. SCHULBERG'S HOUSE

NARRATOR
Why did the studio refuse to let you make the film?

SERGEI EISENSTEIN
You know I learned the real reason Schulberg turned it down, quite by chance, from his son, Budd.

I discovered Budd wandering around the Paramount lot. We talked often. When I told him about my first American failure, "Glass House," he explained that he had overheard the studio manager Uncle Sam say to his father, "My God. B.P. it would cost us a million dollars to build a city made of glass and we couldn't use it as a standing set and write off the cost against other pictures, like our ocean liner, our castle, or our New York Street." That was it.

Try and imagine a cinema that is not dominated by the dollar, a cinema industry where one man's pocket is not lined at other people's expense.

I failed in Hollywood but how could I use their recipes, their commercial calculations?

EXT. SAN PEDRO HARBOR

BERT BRECHT
My name is Bert Brecht. I was born in Augsburg in 1898. I died in Berlin in 1956.

NARRATOR
Why did you come to Los Angeles?

BERT BRECHT
After the Hitler gang took over, I had to leave Germany. When war broke out, nowhere was safe in Europe. We traveled from Finland through the Soviet Union and sailed from the port of Vladivostok on the SS *Annie Johnson* and arrived here in San Pedro on July 21, 1941. I heard Los

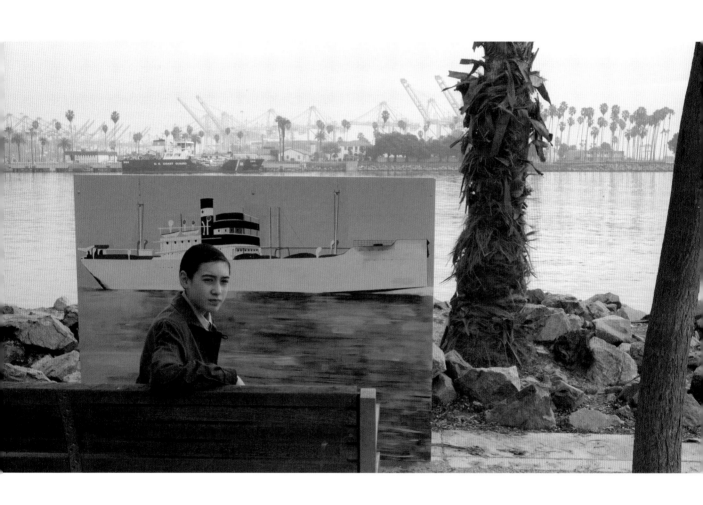

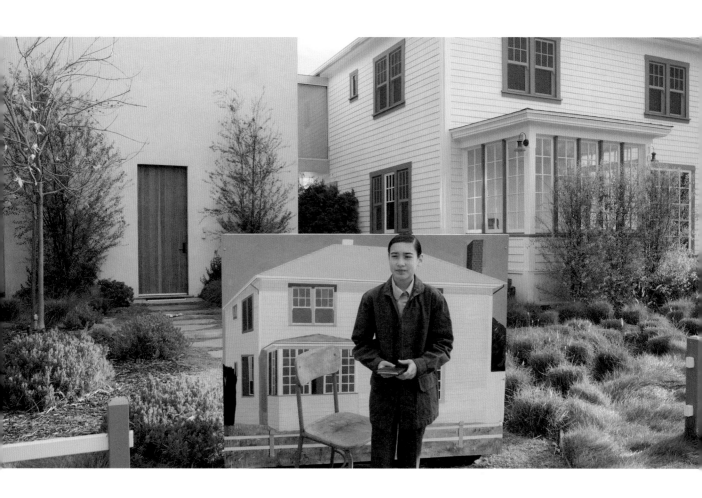

Angeles was cheaper than New York with more opportunities to earn a living.

On the way Grete Steffen died in Moscow. She was my collaborator. My friend Walter Benjamin committed suicide in Spain. Such were the times.

I wrote a poem:

I know of course; it's simply luck
That I've survived so many friends.
But last night in a dream I heard those friends say of me: "survival of
 the fittest"
and I hated myself.

I will tell you. I did not like speaking English then and I still don't. When I speak English I find myself speaking what I have learned and not what I want to say, that is, being a "nice fellow," "easy to get along with."

EXT. BRECHT'S HOME, 1063 26TH STREET, SANTA MONICA

NARRATOR

Your old home, what was it like?

BERT BRECHT

The rent was $60 per month. We lived on $120 a month from the film fund. I was paid like an unskilled laborer.

After I died, they published my diary.

(He opens his diary.)

Almost nowhere has my life been harder than here in this mausoleum of easy going.

(He closes the diary.)

That's really all there is to say. You can read it for yourself.

NARRATOR

You wrote the treatment "A Model Family" in 1941. Tell us your ideas about the American family home.

BERT BRECHT

(Flipping through the pages of his diary impatiently) A universally depraving, cheap prettiness prevents people from living in a halfway cultivated fashion, that is, living with dignity. Here you feel like Francis of Assisi in an aquarium, Lenin in the Prater, a chrysanthemum in a coal mine or a sausage in a greenhouse...even the fig trees sometimes look as if they had just told and sold some contemptible lies.

In this country, houses don't become someone's property by being lived in, but by means of a check. The houses are just extensions of the garages. Here everything is prefabricated. Time is money, prefabricated types are assembled, rehearsals are a matter of patching things together.

NARRATOR

Despite everything you worked very hard here in Hollywood, you wrote poems, plays, and fifty film treatments.

BERT BRECHT

What else were we to do? Boredom drove me to productivity. For example, when my friend the composer Hanns Eisler and I met up and had fifteen minutes with nothing to do I'd say, "For God's sake, what shall we do now!" I was in despair. I had to do something, or read, or speak. Boredom made me physically ill.

Hanns said it best, "For émigrés who had nothing better to do than look at themselves for twelve hours a day, the greatest inspiration during the emigration wasn't our understanding of the circumstances of class, nor our true and, I hope, decent fight for socialism against fascism, but just this tormenting—as a Marxist I ought to say 'reality'—this tormenting boredom. This is the origin of our productive power."

Eisler gave me the idea for my Hollywood elegies. He said, "This is the classic place in which to write elegies. There are the Roman elegies by

Goethe. We have to do something similar. There's a price to pay for living in Hollywood. You have to describe both sides of it." He set them to music.

EXT. OIL WELLS TRACKING SHOT

> BERT BRECHT
>
> By the sea stand the oil derricks. Up the canyons
> The gold prospectors' bones lie bleaching.
> Their sons
> Built the dream factories of Hollywood.
> The four cities
> Are filled with the oily smell
> Of films.

EXT. AERIAL VIEW STUDIOS

> BERT BRECHT
>
> The village of Hollywood was planned according to the notion
> People in these parts have of Heaven. In these parts
> They have come to the conclusion that God,
> Requiring a heaven and a hell, didn't need to
> Plan two establishments but
> Just the one: heaven. It
> Serves the unprosperous, unsuccessful
> As hell.

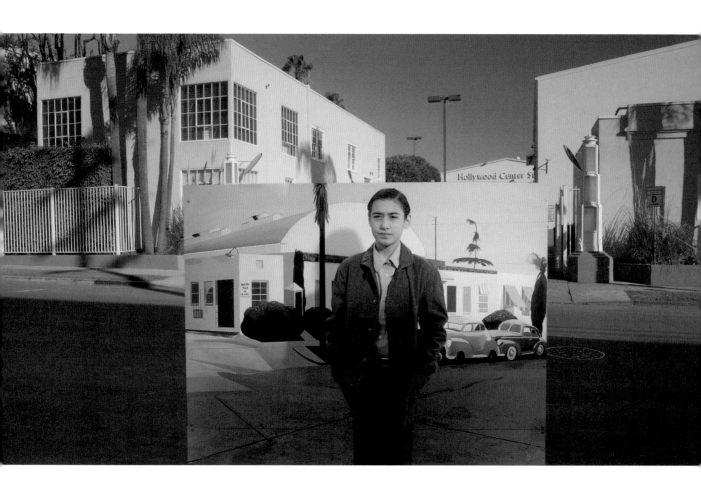

EXT. 1090 NORTH LAS PALMAS AVENUE, FORMERLY THE SITE OF UNITED ARTISTS STUDIOS

NARRATOR

You worked here in 1942?

BERT BRECHT

August 19, 1942. At the office in Hollywood every day. I drove the twelve miles at 8:30 in the morning. At 1 pm sandwiches from home and a swig of Californian white wine. It was hot but we had fans.

My situation was simple. I wrote a poem about it so people would understand. It was called "Hollywood."

Every day to earn my daily bread
I go to the market where lies are bought.
Hopefully I take my place among the sellers.

NARRATOR

What are your thoughts about making movies today?

BERT BRECHT

Nothing has changed. The producers want a story that is original but familiar, unusual but popular, moralistic but sexy, true but improbable, tender but violent, slick but highbrow. What is right is whatever has been shot and is in the can. What is good is whatever gets you a raise in salary.

I wanted to call the picture we were working on "Trust the People" but the studio insists on "Hangmen Also Die."

While I dictate the story, Fritz Lang is negotiating upstairs in the studio with the money men. The figures and the agonized screams can be heard below like in a propaganda film. $30,000—8 percent—I can't do it.

The studios were consciously hypnotizing a country at war. But how can people take action when they are asleep? I was determined to wake them up.

I insisted, the audience needs realism, not illusionism. Quite simply the trouble with the illusionism of the movies is that everything is in colloquial prose, completely natural just like life. What is the use of that?

The audience just assumes that is just how things are and man is naturally the victim of climate, of passion, of property. Nothing one can do to change it. The truth might be in there but no one can get at it.

NARRATOR

And what is realism?

BERT BRECHT

Realistic art is art that led to an understanding of reality against the ideology and makes it possible to feel, think, and act realistically.

EXT. VERMONT AVENUE TRACKING SHOT

NARRATOR

Brecht's realism shows us that our social life is not natural at all. Instead things are often set up for the benefit of some against others. To get at how things really work means taking them apart and studying them. So realistic art can make the world look quite unfamiliar at first, even funny. For this reason, Eisenstein and Brecht were big fans of Charlie Chaplin.

EXT. VENICE BEACH

SERGEI EISENSTEIN

Let me tell you about an evening with Charlie.

Charlie and I are going to Santa Monica to the Venice festival on the beach. In a few moments we'll shoot at mechanical pigs and throw balls at apples and bottles.

Putting on his spectacles in a businesslike way, Charlie will mark down the score in order to get one big prize, say an alarm clock instead of several small prizes like the plaster of Paris statue of Felix the Cat. The boys will slap him on the back with a familiar "Hello, Charlie."

When I think of Chaplin, it is of his eyes. To understand him one must ask, With whose eyes does Charlie Chaplin look on life? How are his eyes set?

I mean his mental eyes, to images of things, spontaneously and suddenly—outside their moral-ethical significance, outside valuation and outside judgment and condemnation, as a child sees them through a burst of laughter. In that, Charlie is outstanding, inimitable and unique. Only Chaplin sees this way.

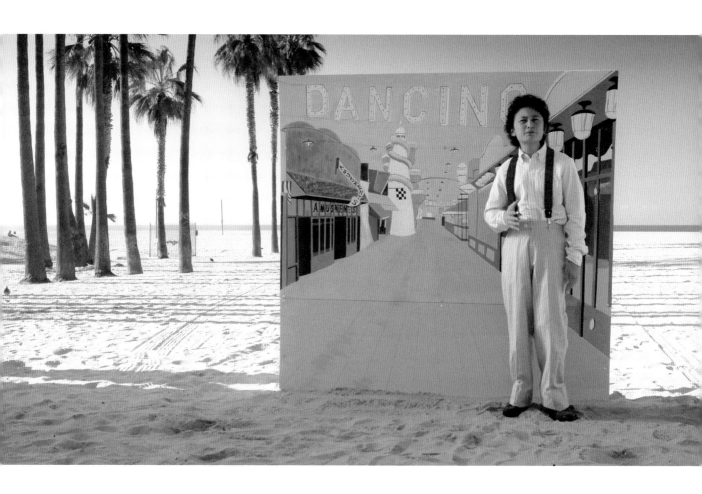

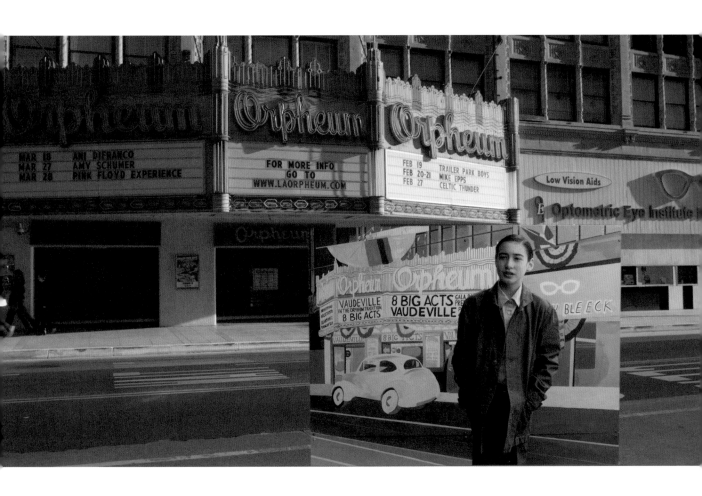

Chaplin's partner is not the big, terrible, powerful, and ruthless fat man who, when not filming, runs a restaurant in Hollywood. Chaplin's partner is still bigger, more terrible, powerful, and ruthless. With this partner—reality—Chaplin performs an endless series of circus stunts for us. Reality is like a grim "white-faced clown." It seems wise and logical, prudent and far-seeing. But in the end it is fooled, ridiculed. As its guileless and childlike partner, Chaplin gains the upper hand.

When we went out together on his yacht, he told me he does not like children! The man who made *The Kid* does not like children. He is a beast! But who normally does not like children? Only children themselves.

EXT. 842 SOUTH BROADWAY, ORPHEUM THEATER

NARRATOR

I thought you didn't like the movies.

BERT BRECHT

No, no. I used to go to a lot of matinees, double bills two or three times a week before the prices went up. I liked gangster movies. They were the most accurate documentary representation of social reality in America.

NARRATOR

Who are the right actors for your realistic drama?

BERT BRECHT

The actor must quote, he must describe life as it is, an unvarnished account. Through his actions, the actor should demonstrate who he is and what he represents. In America, I had no use for the screen actors. I preferred the burlesque shows, vaudeville and musicals. Like the ones that used to play here at the Orpheum.

One could see whole families—mother, father and children—yelling in joyous unity at a stripper in a burlesque house to "take it off." The vaudeville players knew how to communicate and entertain without swindling the audience into a state of belief. They involved the audience without trying to hypnotize it.

But there was one screen actor who was perfect, Chaplin.

EXT. HENSON STUDIOS, SITE OF THE FORMER CHAPLIN STUDIOS

NARRATOR

Did you meet Chaplin?

BERT BRECHT

Hanns Eisler was a good friend of Charlie. We met many times. We watched him work here. He was a very serious man. I noticed that when Charlie spoke about a film in which he acted, as well as directed, he identifies with the director, not the actor. He does not see himself as the Little Tramp.

(Bert acts out how Chaplin directed himself.)

The Little Tramp is a third person, who he, the director, makes receive the buffets of fortune.

The Little Tramp showed us how the world works with his gags and pratfalls. This is exactly how the actor in my epic theater must perform.

Laughter is very important. A drama where you can't laugh should be laughed at.

Let me tell you a story. Charlie invited two hundred of his friends to a private screening of his film *Monsieur Verdoux*. Among them were very wealthy people, the most important men in the film industry. In certain scenes—for instance when the bankers jump out of the windows during the economic crisis—you could hear just two people laughing, me and my friend Hanns. Everyone else kept quiet because there were bankers in the audience watching the film too. So you see we were the most perceptive laughers.

Of course we only laughed at Chaplin's jokes that had a social meaning, so that Charlie, to whom it was very important to be admired for his jokes, became more radical in our company.

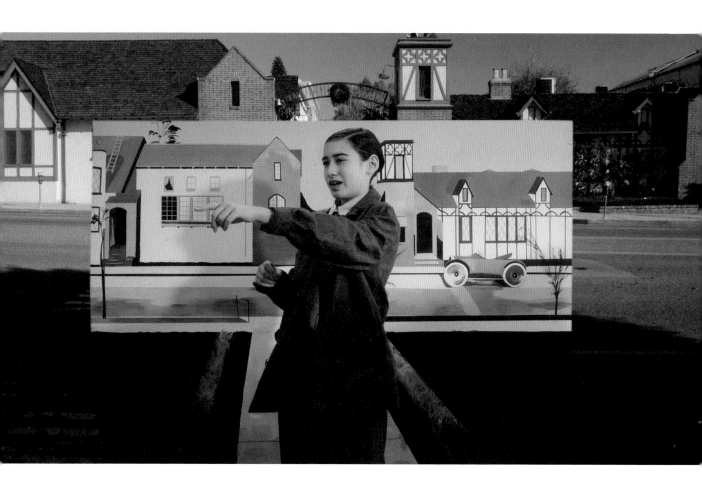

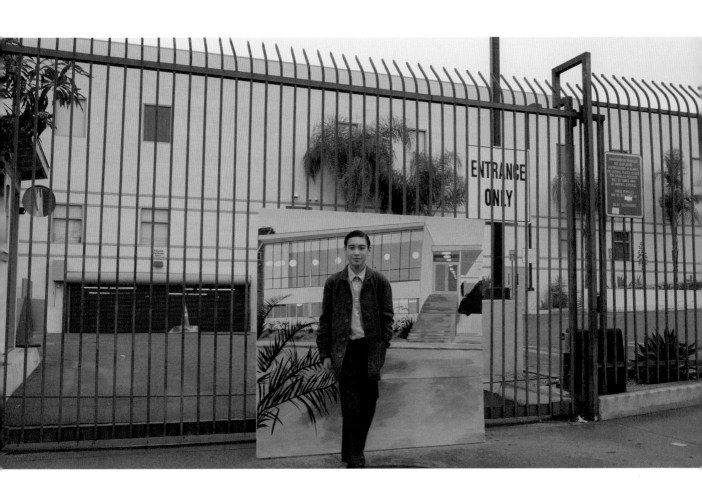

EXT. CORNER OF SOTO STREET AND MICHIGAN AVENUE, FORMERLY A JEWISH COMMUNITY CENTER

BERT BRECHT

You are wondering why I brought you here to a parking lot?

There is someone I want to remember. New Year's Eve 1941, I went to a party here at the Soto-Michigan Jewish Community Center. A poet sang one of my songs, "To the German Soldiers in the East."

Mr. Samuel Bernstein, a tailor sitting in the audience, took pity on this poorly dressed refugee who stands before you and sent me a suit with an offer to alter it to fit. It was the suit that Mr. Bernstein had worn at his own wedding.

I repaid him with a poem called "Friends Everywhere."

EXT. 75TH STREET DRIVING SHOT

BERT BRECHT (V.O.)

The Finnish workers
Gave him beds and a desk
The writers of the Soviet Union brought him to the ship
And a Jewish tailor in Los Angeles
Sent him a suit: the enemy of the butchers
Found Friends.

SOURCES

Brecht, Bertolt. *Bertolt Brecht Poems Part Three 1938–1956.* Edited by John Willett
 and Ralph Manheim. London: Eyre Methuen, 1976.
———. "The German Drama: Pre-Hitler." *New York Times* (November 24, 1935).
———. *Journals 1934–1955.* Edited by John Willett. Translated by Hugh Rorrison.
 London: Bloomsbury Methuen Drama, 1993.
Bulgakowa, Oksana, and Dietmar Hochmuth, editors. *Sergei Eisenstein: Disney.*
 Translated by Dustin Condren. Berlin and San Francisco: Potemkin Press, 2011.
Bunge, Hans, and Hanns Eisler. *Brecht, Music and Culture: Hanns Eisler in Conversation
 with Hans Bunge.* Edited and translated by Sabine Berendse and Paul Clements.
 London: Bloomsbury, 2014.
Eisenstein, Sergei. "Chaplin's Vision." In *The Legend of Charlie Chaplin.* New Jersey:
 Castle, 1982.
———. "The Dinamic Square: Suggestions in Favour of New Proportions for the
 Cinematographic Screen Advanced in Connection with the Practical Realization of
 'Wide Film.'" *Close Up* (March 1931).
———. *Glass House—Du projet de film au film comme projet.* Dijon, France: les
 presses du réel, 2009.
———. *Notes of a Film Director.* Moscow: Foreign Languages Publishing House,
 1946.
———, Vsevolod Podovkin, and Gregori Alexandrov. "A Statement on the Sound-
 Film." In *Film Form: Essays in Film Theory.* Edited and translated by Jay Leyda.
 New York: Harcourt, 1977.
Lyon, James K. *Bertolt Brecht in America.* New Jersey: Princeton University Press, 1980.
Montagu, Ivor. *With Eisenstein in Hollywood.* New York: International Publishers,
 1974.
Schulberg, Budd. *Moving Pictures: Memoirs of a Hollywood Prince.* Chicago: Ivan R.
 Dee, 1981.
Seton, Marie. *Sergei M. Eisenstein.* New York: Grove Press, 1960.

CLOSE UP

The Only Magazine Devoted to Films as an Art

Price 1 Shilling

Vol. VII No. 2 August 1930

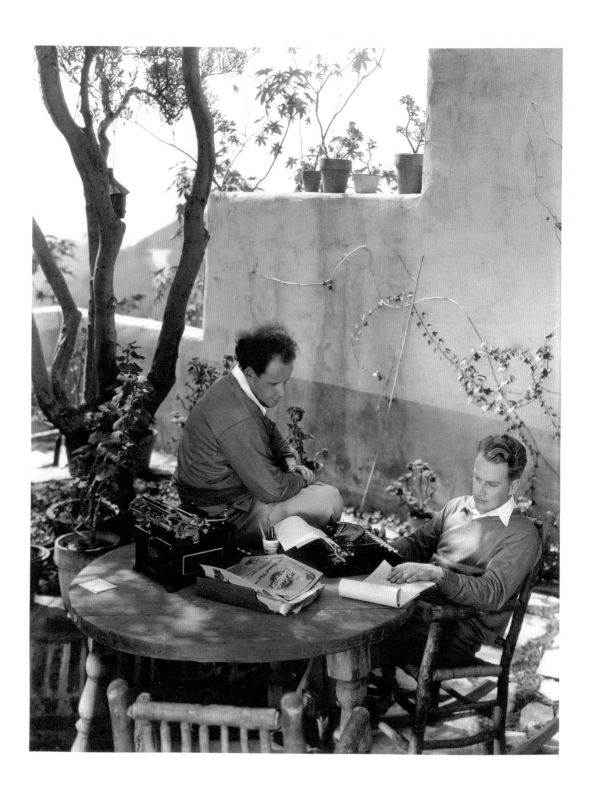

EISENSTEIN IN HOLLYWOOD

Clifford Howard, *Close Up*, August 1930

What will Eisenstein do to Hollywood? Or what will Hollywood do to Eisenstein? That the two should be brought into an attempted confraternity is a circumstance of uncommon moment. An irresistible force meeting an immovable body.

Cinema history records the names of many foreign directors brought to Hollywood on the strength of personal achievements in their native environment. Tourneur, Dupont, Murnau, Berger, Stein, Lubitsch, Fejos, Korda, Curtiz, Seastrom. These are some of them—each received on his arrival with open arms and a fanfare of publicity trumpets. Time passes. What becomes of them? One of two things—either they "go Hollywood" or they go home. They do not remain if they remain what they were. Only Lubitsch, as a singular exception, has succeeded in holding on while at the same time retaining in some degree his distinctive cinema personality.

Individualism has no place in Hollywood. American pictures are pattern-made. The patterns are dictated by the box office, and the box office is the composite voice of the crowd expressed in the clink of silver coin. There is no arguing with the crowd. It wants what it wants. And mostly it doesn't want art nor education nor uplift nor cinematic stylism, nor does it care two pennies for any picture because of its director, unless perhaps it be Cecil DeMille. And Hollywood has grown rich and great and unshakable because it knows this and accepts it and profits by it.

Yet, of all persons in the world, Hollywood has opened its gates to Eisenstein. The most dynamic individualist in the history of motion pictures. The personification of sublimated cinematic art. The most puissant protagonist of social education by means of the screen. In short, the embodiment of every fundamental taboo of Hollywood. And Eisenstein, on his part, has come to Hollywood, of all places in the world the least in accord with his ideals and purposes and philosophy.

Paramount publicity photograph of Eisenstein and Gregori V. Aleksandrov at the house they shared in Coldwater Canyon, Hollywood, 1930. Aleksandrov was Eisenstein's stage and film assistant in the 1920s. He later directed Stalin's favorite musicals.

A strange paradox, indeed. Eisenstein, the Russian socialist, an impregnable individualist. Hollywood, giant offspring of capitalism and commercialism, the subjugator of the individualist and enforcing a system of collectivism beyond anything yet attained in communistic Russia. Eisenstein and Hollywood. The positive and negative poles of the cinema. The one thinking in terms of art, of philosophy, of sociology. The other, with no comprehension of these terms, devoting its energies and experience to supplying agreeable entertainment as a commodity to a self-satisfied world in its moments of pastime and mental inactivity.

The outcome of this equivocal alliance will be awaited with more than usual interest. To the great crowd, however—the many millions whose daily patronage of the cinema insures Hollywood's existence—it is a matter of little or no moment. The vast majority of the American public as yet know nothing of Eisenstein. They have not heard of him. His *Potemkin*, his *Ten Days that Shook the World*, his *Old and New* have had but scant showing here and relatively scant appreciation. They are not to the American taste, either in subject or in treatment. Russia and the United States are socially and psychologically antipodal.

However, true to its gift of showmanship, Hollywood will see to it that the Americans are made acquainted with its latest acquisition. Following the example of Barnum, it is ever on the lookout for whatsoever or whomsoever is exploitable as an attraction. Eisenstein is its latest find, and already a publicity campaign is under way to arouse an interest and curiosity in "the man who has taken Europe by storm and whose pictures are today the subject of worldwide discussion." And by the time his Hollywood-made film is released, the crowd will have been drilled into an eager readiness to see it. Its verdict, however, is unforeseeable. But whatever it may be, Hollywood will not lose on the film, though it may lose Eisenstein.

It was my pleasure to call on him, at the Paramount studio, a day or two after his arrival. My immediate impression of him, against an already prepared background of acquaintanceship with his work and reputation, was that of a man who, although in Hollywood, was not of it and never would be. In the formal, conventional quarters of his two-roomed office he reminded me of nothing so much as a caged lion. Not that he was himself yet conscious of captivity or restraint. That consciousness will come later, with experience. I have seen many a robust genius—director, author, artist—cooped up in a regulation studio office under orders to go ahead and create, "and make it snappy!" but never have I seen one to whom this environment with its stark, unmitigated implications of commercialism seemed so great an impertinence as it does to this leonine Russian.

GLASS HOUSE

Paramount Pictures

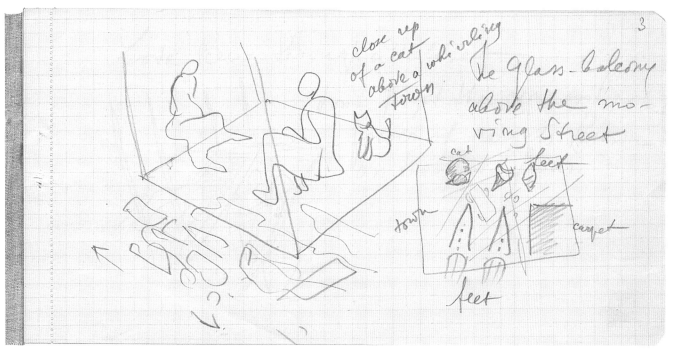

close up
of a cat
above a whirling
Town

the Glass-balcony
above the mo-
ving Street

cat
feet
town
carpet
feet

Love scene through a W. closet

don't forget the compositional
power of carpets thrown
on the glass floor.

17/ "In Surch of the new angle"
4

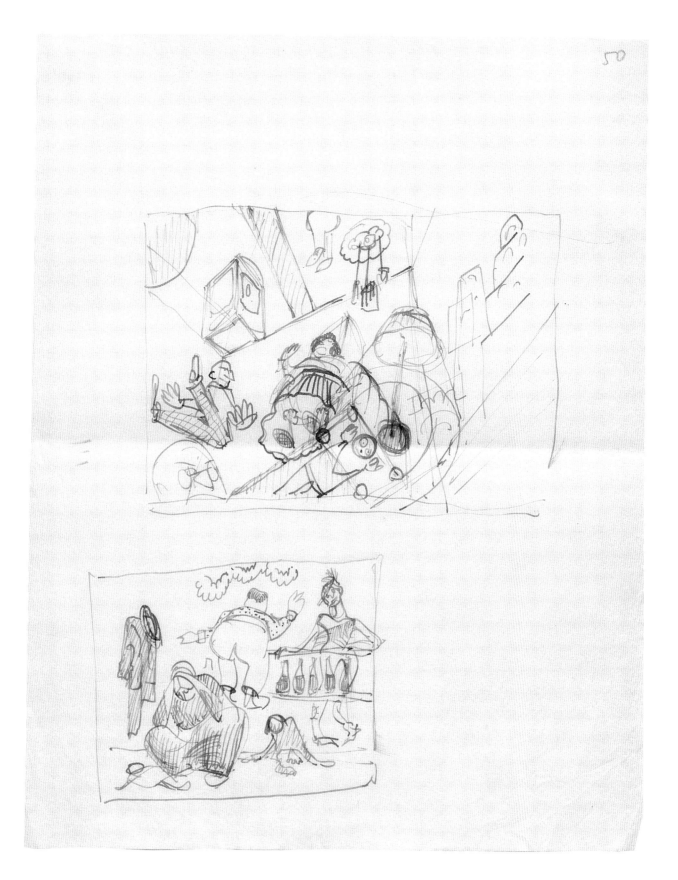

Robot — the mechanic man
— as the only "human" being.
He (Robot) cannot stand
the atmosphere of the Glass House
and he gives the first strike
to the house, and he alone
persists after the crash ——
as the introducer of the new
spirit of new humanity.

————

The poor girl crying at
his breast.

————

Robot Parade (comme les
lions dans des cinémas).

In the „God-Father & Jesus" va-
rianto:
The old man does the house
and gives it to „Men".
Then disappears.
 J. comes & dies etc.
Robot breaks house — per-
sists — and taking off his
„mask" — is the old man.

The human „escapes" of
Robot during the play:
 he consoles the girl by
an usual mechanic move-
ment (p. ex. lifting & downing

Robot — the mechanic man
— as the only "human" being.

<u>He</u> (Robot) cannot stand
the atmosphere of the glass house
and he gives the first strike
to the house, and he alone
persists after the crash ———
as the introducer of the new
spirit of new humanity.

———

The poor girl crying at
<u>his breast</u>

Robot Parade (comme les
lions dans des cinémas).

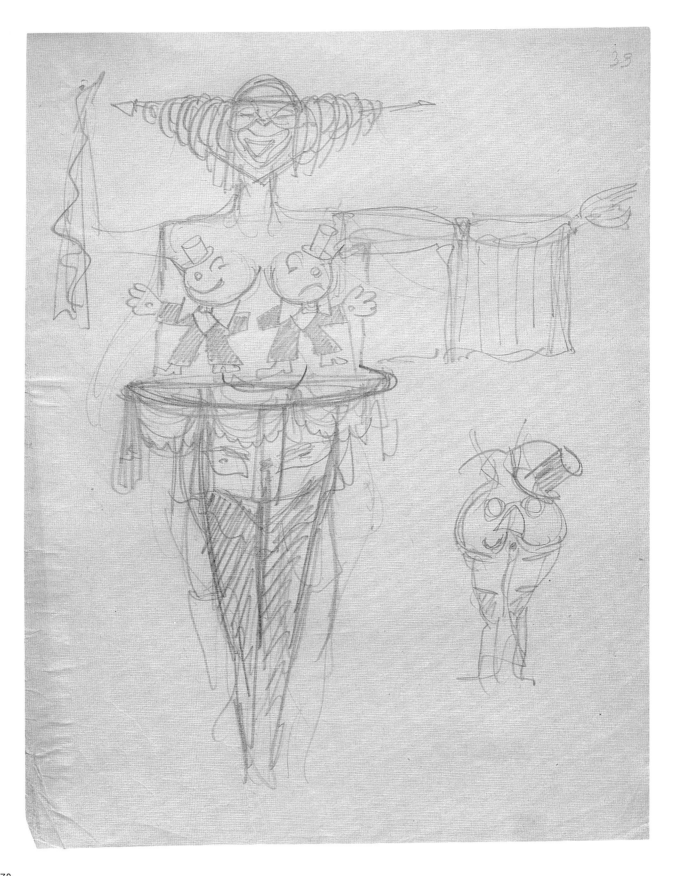

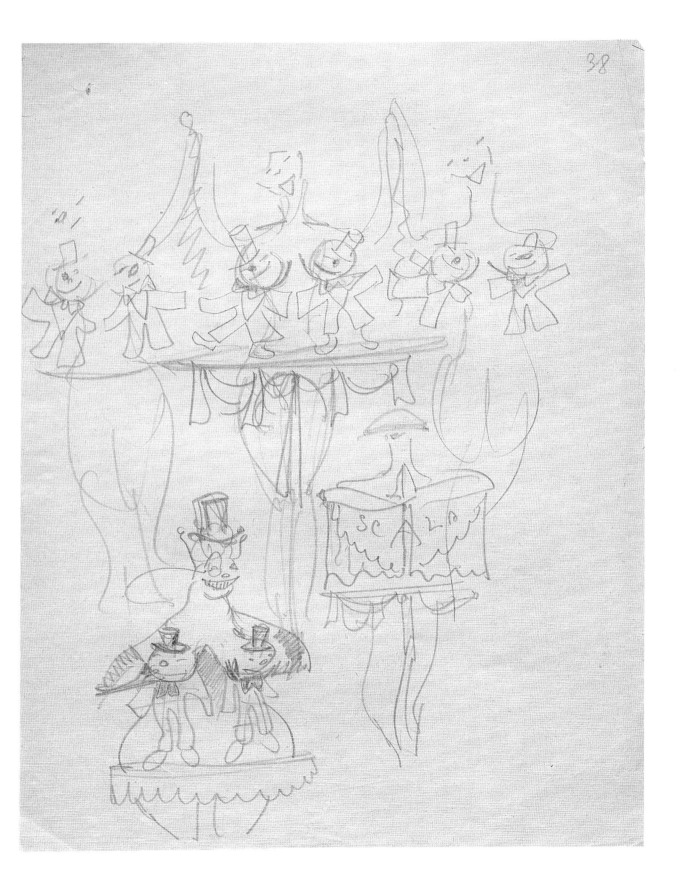

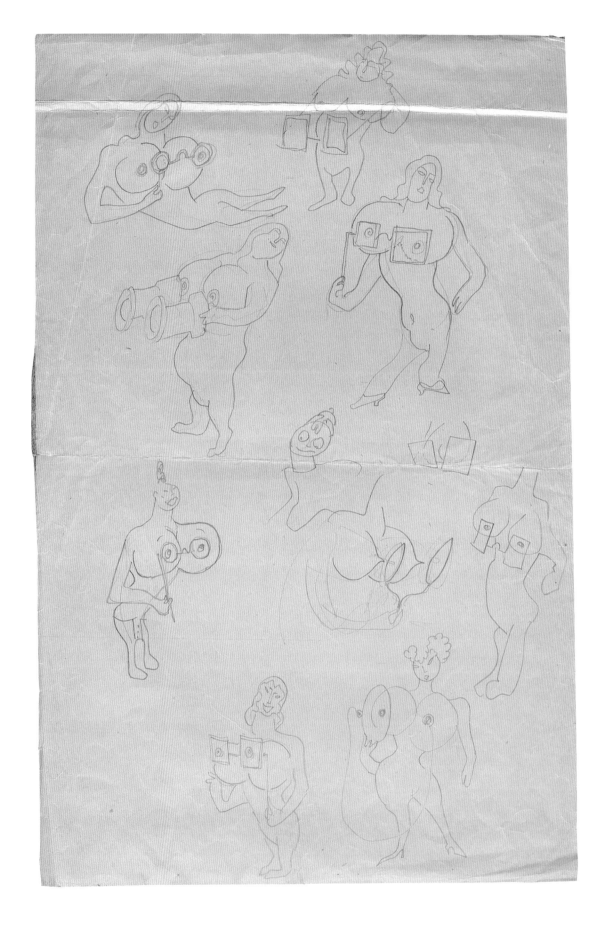

идея 1.

Glasshouse.

диссерт. и Set. 1929-30.

идея 2

раздавли
ивают
(свет
снизу)

объем
и
контробъем

Glass House, 2014
Written and directed by Zoe Beloff, inspired by Sergei Eisenstein's notes for
a movie to be titled "Glass House"
Cinematography by Eric Muzzy
Cast: Jim Fletcher (Sergei Eisenstein, the Architect, and the Robot), Kate Valk
(Walt Disney, Mickey Mouse, the Poet, the Robot)
Music composed by Susie Ibarra
The film can be viewed at http://aworldredrawn.com

Eisenstein looks on as Disney himself acts the role of Mickey while artists attempt to capture the expressions of their boss.

All All All Attention to the Glass House!

Eisenstein sketches feverishly—the glass balcony over the moving street—absolutely new angles of view!

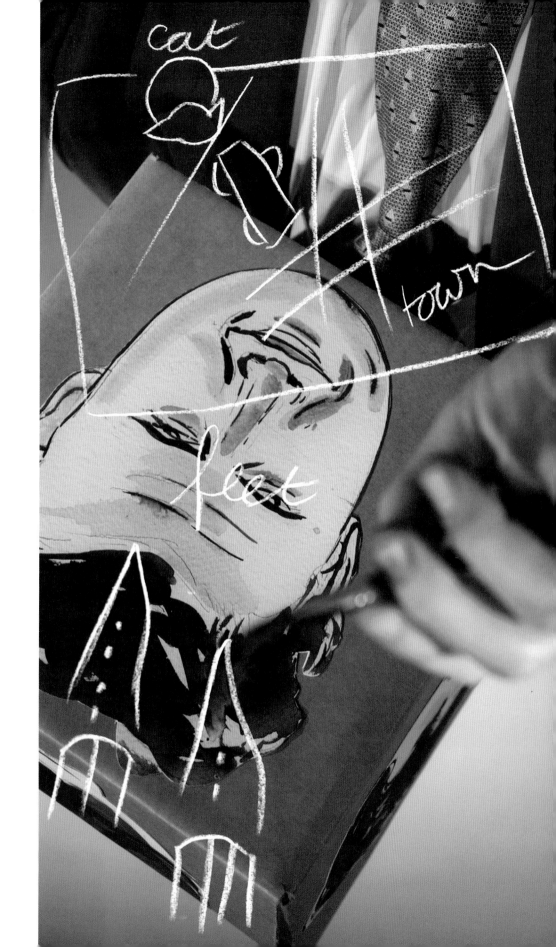

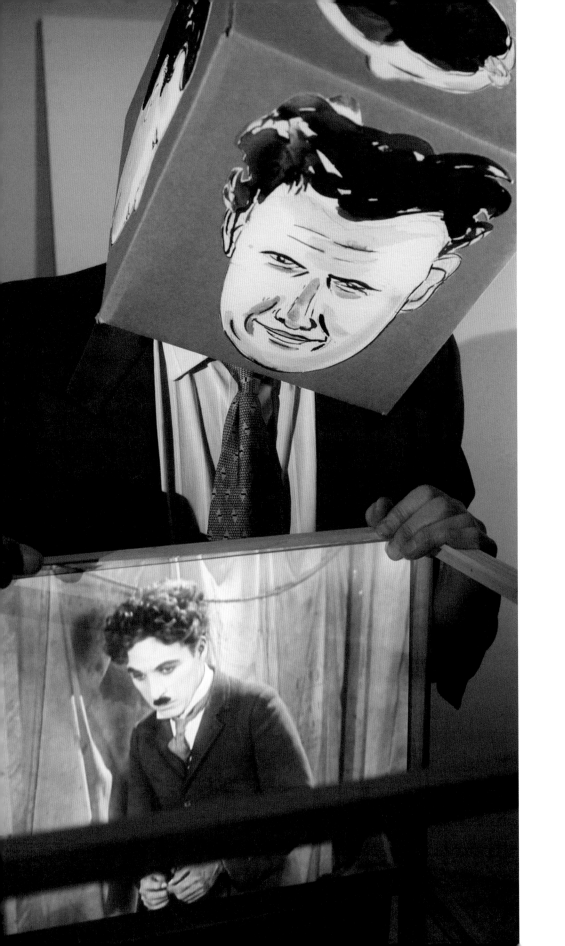

Chaplin's mansion became Eisenstein's second home. Sergei Mikhailovich explains the Glass House to Charlie.

Symphony of glass. The conflict of form and content. The reproduction not of the image but of process, just as Marx describes the economy.

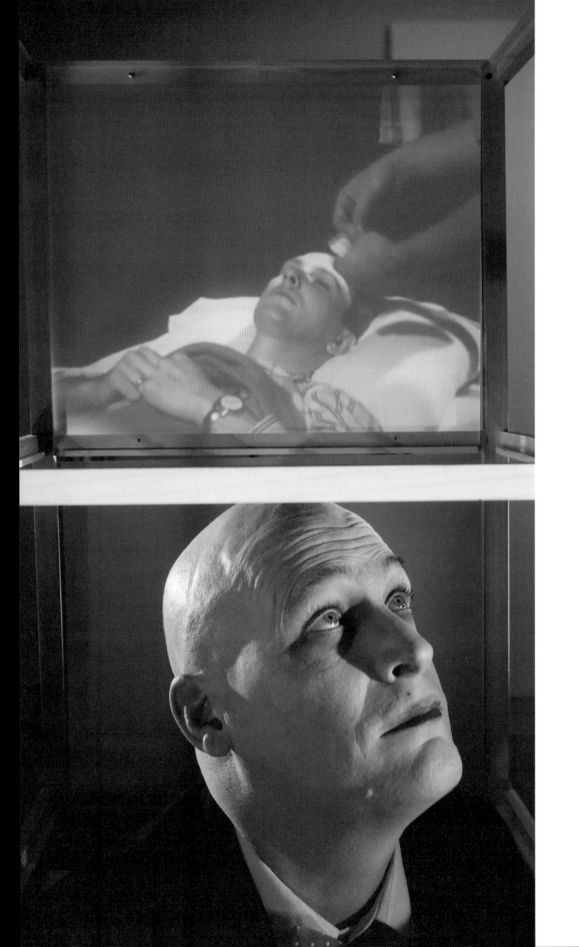

The Architect builds the house. Inside, indifference to others is established by showing that the characters do not see one another through the glass doors and walls because they do not look—a developed "non-seeing."

The Poet opens our eyes!

The Glass House cabaret—the twin brothers sneezing milk!—the tits have absolutely the most erotic impact!

The Poet's impassioned speech results in the formation of a nudist association.

PLOTS

PLOTS

PLOTS

The residents begin to see each other, to look at and pay attention to each other, and in a capitalist sphere this leads to chaotic hatred, violence, and catastrophe.

The suicide of the Poet. She sees no one, but all eyes are on her, watching with bated breath.

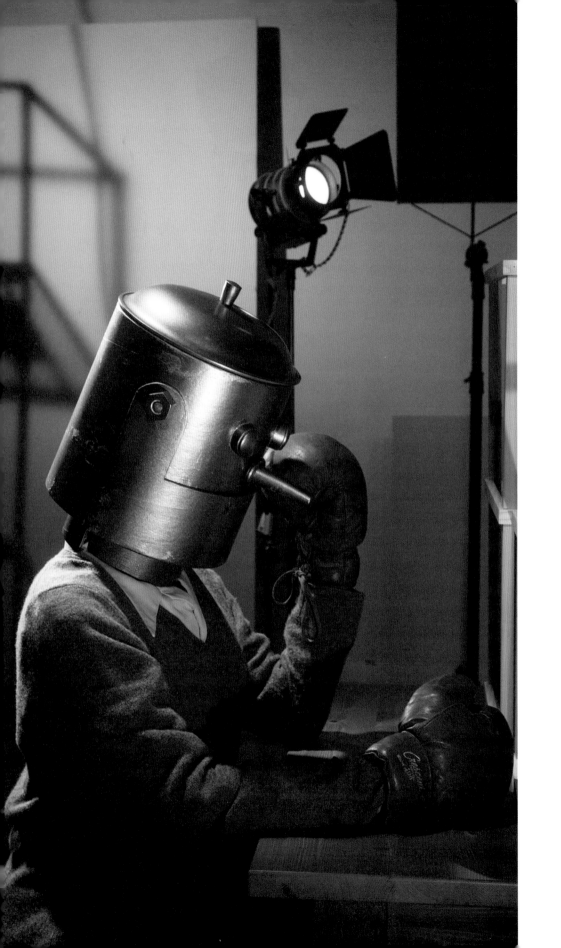

The Robot alone survives as the introducer of a new spirit of humanity.

Eisenstein undergoes high-speed psychoanalysis with one of the most renowned doctors in the States. He writes, "I've spent ten days being depressed. Now I'm starting to get better. It seems that I may be liquidating a whole bunch of my neuroses forever."

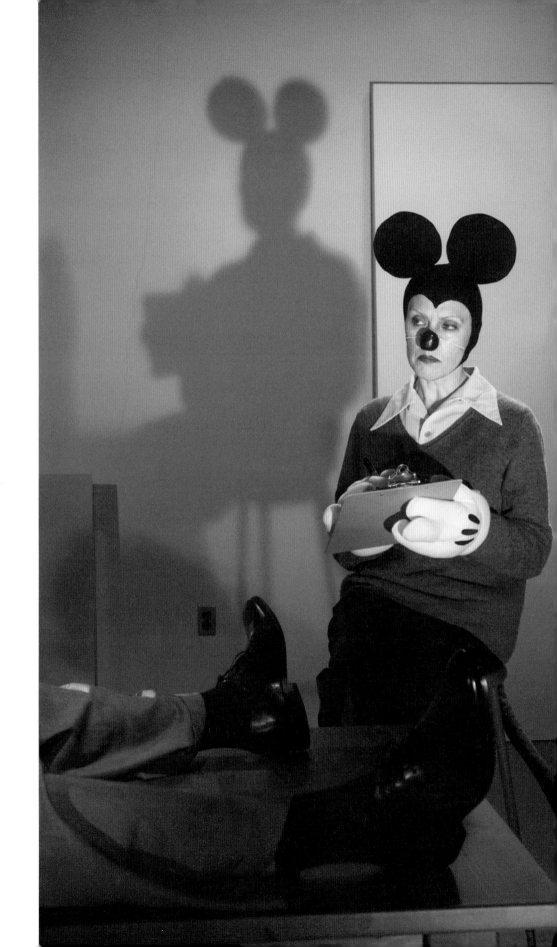

A double oedipal projection. Eisenstein's father was an architect and he had mocked his father's design.

The robot—the new man—continues to grow stronger and more powerful, an unfathomable architecture of circuits, wireless transmission, and reception: a monstrous data-mining machine.

30 коп.

С. МАРШАК

ПОЧТА

МОЛОДАЯ ГВАРДИЯ
6ОЕ ИЗДАНИЕ
ОГИЗ

МОСКВА-ЛЕНИНГРАД

РИСУНКИ **М. ЦЕХАНОВСКОГО**

THE POTENTIAL OF *POCHTA*

Unlikely Affinities Between American and Soviet Animation, 1929–1948

Hannah Frank

In several essays from the early 1930s, the American film critic Harry Potamkin assailed the nearly universal embrace of Walt Disney. According to Potamkin, films in the *Mickey Mouse* and *Silly Symphonies* series, beloved by the likes of Sergei Eisenstein and Walter Benjamin, amounted to little more than "lycanthropy with a bit of puerile sophistication."[1] The cult of the cartoon, to which e. e. cummings and E. M. Forster also subscribed, signaled a profound immaturity on the part of the viewing public. Moreover, the cartoons were themselves immature—"simplistic" and "coddled" and "rudimentary" and "inarticulate." Their characters bobbed up and down in meaningless patterns of "perpetual motion," all set to "an unoriginal turkey-in-the-straw musical motif."[2] This is true of even the most celebrated of Disney's cartoons, such as *Skeleton Dance* (1929), in which the titular performance unfolds as a series of tableaux. The plastic bodies of the performers, skeletons and black cats and owls, stretch in every direction, but their movement within the space of the film's cemetery setting is more or less delimited by the rhythmic pulsations of the music and the horizontal axis of the screen.

Potamkin had an alternative in mind. "While we are gurgling over *Mickey Mouse*," he explained, "the Soviet animated cartoon is busy with the transmitting of ideas."[3] For Potamkin, the strongest antidote to Disney's juvenile productions was Mikhail Tsekhanovsky's film *Pochta* (*Post* or *Mail*, 1929). *Pochta* details the circuitous route taken by a letter from a boy to his grown friend, a butterfly enthusiast. The boy encloses a caterpillar in the envelope, which winds its way through the Soviet Union, Germany, England, Brazil, and back again. By the time the letter has reached its destination, the caterpillar has turned into a butterfly. While *Pochta* was

Pochta, by Samuil Marshak, illustrated by Mikhail Tsekhanovsky, 1927.

itself an adaptation of a children's book (written by Samuil Marshak with illustrations by Tsekhanovsky), Potamkin saw in it a sophistication that signaled animation's potential as an autonomous art form. Vladimir Deshevov's musical score, which, along with a voiceover by the absurdist writer Daniil Kharms, was added to the film in 1930, could stand on its own as an "original modernist composition,"[4] one far removed from the clichéd pastiches of Disney. Equally important were the film's visuals, which were liberated from the rigid frontal displays of the *Silly Symphonies*: "The designs move in all directions, they alternate in diagonals, circles, as well is in the normal horizontals."[5] The visual style of *Pochta* is more closely affiliated with the poster art of Mayakovsky, the montage of Pudovkin, and the constructivism of Rodchenko than the popular comics from which Disney drew.

What most clearly distinguishes Tsekhanovsky's film from those of Disney is his use of cutout animation. By 1930 most American studios had made the transition to cel animation, in which foreground elements are rendered on individual sheets of transparent celluloid, called "cels," and then overlaid on static background paintings and photographed. For instance, a skeleton's body might be painted on one cel, its skull on another. This stack of separate paintings would then be placed on a background on which had been painted a graveyard. With each successive frame, one or more of the cels would be replaced by the next in the series. While this process was highly labor intensive, the fragmentation of its parts meant it could be divided across a factory of artists and technicians—one group of animators was responsible for the initial sketches, another for tracing, a third for painting. Cel animation technique was thus amenable to standardization, mechanization, and high-volume production. In the United States, animation was an industry as much as it was an artistic medium; Disney himself likened his studio to a Ford factory.[6] Furthermore, the disjunction between the foreground and background gave cel animation technique a distinctive style. While the backgrounds were painted in watercolor, the foreground elements were painted with compounds that had both to adhere to the cellulose nitrate (and, later, acetate) sheets without cracking or smearing and to come off easily so that the cel could be reused. As a consequence, the characters appear not to belong to the worlds in which they are placed. The skeletons of *Skeleton Dance* have thick black contours and opaque white bones, while the tombstones marking the graves from which they emerge are rendered in subtle gray tones. It is this

Skeleton Dance, 1929.

disjunction that led Potamkin to criticize Disney's films as "simply crude line-drawings and dull wash," and Eisenstein, writing a decade later, to reflect on how even his favorite early shorts disturbed him with their "total *stylistic rupture* between the background, painted in such a weak, childish manner, and the brilliant perfection of the movement and drawing of the moving figures in the—foreground."[7]

In the Soviet Union, by contrast, most animated films of the period were made by no more than three or four trained animators and featured cutout figures with hinged joints, which were manipulated frame by frame before the camera. Because they could move only at fixed places—elbows, shoulders, hips, knees, jaws—the characters were somewhat constrained and even mechanical in their locomotion. American cartoons, on the other hand, were loose-limbed and uninhibited. They could shift their shape at a moment's notice. It was this aspect of cel animation that Eisenstein and Benjamin most admired. For Benjamin, the fluidity of Mickey Mouse's form was a utopian alternative to the breakdown of the human body under capitalism; he was the dream, not the nightmare, of technological development and rationalization, proving "that a creature can still survive even when it has thrown off all resemblance to a human being."[8] Eisenstein called this quality "plasmaticness," which for him transcended contemporary economic and political conditions, returning the viewer to a pre-Enlightenment state, unshackling the body and granting it "the ability to dynamically assume any form."[9] It would perhaps surprise Potamkin to learn that Tsekhanovsky was himself a student of Disney's films, which he watched closely in order to learn the methods of "stretching" and "squashing." As Tsekhanovsky reflected in his diary, Disney "never offers distortion for the sake of distortion but rather to prove (or to demonstrate) the possibilities of

Pochta (Mail), 1929.

animation. This distortion (the expansion and contraction of figures) serves as expressiveness, not as trickery."[10] Nonetheless, he wanted to improve on Disney—to harness the expressive possibilities held out by Disney in service of intellectually rich and artistically pure animation.

What held Disney back, at least according to Tsekhanovsky and his peers, was the very industrial system that he had helped create. As the film critic Adrian Piotrovsky forcefully put it in 1929, the production of "cinema animation under the conditions of capitalist cinematography" necessarily led to "pedestrian output" and "aesthetic dilettantism."[11] Tsekhanovsky, likewise, claimed that American film could not help but be subordinated to "ideology" of its master, namely, "the commercial interests of the American film industry."[12] The bottom line was, indeed, *the bottom line*—not art. Unlike Disney, Tsekhanovsky didn't have to answer to industrial or economic pressures. He had the license to direct animated films with edges so sharp that they'd make "Mickey Mouse, in comparison, seem to have the aesthetic of treacle."[13] Tsekhanovsky would not, therefore, have disagreed with one of Potamkin's most damning dismissals: "There is too much gag in the Disney film and not enough idea."[14]

This, at least, was the dream. What Disney teased, Tsekhanovsky would realize. But it is hard to see how American cel animation had any influence on *Pochta* (which was released the same year as *Skeleton Dance*), so distinctive is Tsekhanovsky's style. Tsekhanovsky builds his own rich vocabulary out of the technical limitations of cutout animation. For instance, he exploits what might seem to be cutout animation's fundamental constraint—the rigid, mechanical movements of its figures—to comic effect. The overall form of the rotund German postal worker of the picture book is

Pochta (Mail), 1929.

translated into black and white unchanged. His stride is still purposeful; one leg juts out, then the next, and he holds the letter in his left hand, his satchel at his side with his right. While this is not "character animation" per se—the term used to describe how Disney animators developed their characters' personalities through movements both small and large—the clarity of the graphic design and the unerring pace of the animation combine to give the postman weight and energy that belie his pictorial origins.

Throughout the film, figures are set against a spare background lacking any depth cues. What few columns, staircases, or palm trees punctuate the setting are decorative elements that dynamize the flat composition, rather than locate the character in three-dimensional space. For Tsekhanovsky, empty spaces presented a field for experimentation in which he could play with fundamental conceptions of size and shape. In *Pochta*, characters of dramatically different scales appear together in a single frame, presaging Eisenstein's use of the wide-angle lens in *Que viva México!* (1932). In one shot, a character hears a knock at the door. An extreme close-up of his face in profile fills the right half of the frame, while in the upper left materializes a tiny figure—the source of the knock, a postman with a letter to deliver. The wild contrast in scale pulls us diagonally up across the frame of the image, toward the postman, and then back down again, as if the image were itself reverberating.

And, significantly, Tsekhanovsky does not use cutout animation alone. On the outside of the envelope, the boy draws a jittery likeness of its contents, which we see emerge line by line before our eyes through stop-motion animation.[15] This same technique is used in the following shot, when the boy helpfully adds a picture of the addressee (including butterfly net) and his loyal poodle. The scene concludes with another stop-motion

Pochta (Mail), 1929.

sequence in which the envelope crawls across the table like a caterpillar. In addition, Tsekhanovsky makes frequent use of rapid editing—itself another form of frame-by-frame manipulation, or montage taken to its logical extreme—to underscore narrative turmoil. Nowhere is this clearer than in a scene of a storm striking the sea. A ship, which bears the letter's intended recipient, is rendered in white against a black sky, creating a sinister, otherworldly evocation of the shots printed in negative in F. W. Murnau's *Nosferatu* (1922). A series of superimpositions simulates the tossing and turning sea, alternations of black and white suggest blinding bolts of lightning, and the duration of shots quickly decreases, giving an overall impression of the storm's onslaught, the sea's turbulence, and the resultant somatic effects—nausea and shock. But perhaps the most arresting sequence in *Pochta* comes when a postal train enters a tunnel. The putative camera is aligned with the train itself, a staging similar to the "phantom rides" of early cinema. The train tracks, stretching toward the vanishing point, resemble an unfurled filmstrip; as the train makes its way through the tunnel it is engulfed in a mesmerizing black-and-white swirl akin to Marcel Duchamp's rotoreliefs. By mostly forgoing the representation of human figures and deriving their primary power from dynamic staging and editing, these latter two sequences most clearly embody the expressive potential of Tsekhanovsky's film. And even the use of stop-motion at the film's start has its own charm—Tsekhanovsky does not shy away from mixing animation techniques and graphic styles for comic effect. There seems, in short, to be little here that resembles anything in the cartoons of Disney and his American contemporaries.

. . .

Pochta (Mail), 1929.

Alas, just a few years after *Pochta*'s release, there was no longer a place for Tsekhanovsky's experimentation in Soviet animation. It fell victim to socialist realism. At the 1933 All-Union Conference on Comedy, Russian animators were exhorted to "Give us the Soviet Mickey Mouse!"[16] To do so, though, was not as simple as creating a cute cartoon character. That character had to be made to move, and it had to move like Mickey Mouse. Earlier attempts by Soviet animators to create popular serial characters had failed to catch on with audiences, and their ability to create a "cinema for the millions" to rival the viewers of American animated cartoons was severely hampered by time- and labor-intensive production processes that were the norm at Soviet animation studios. As early as 1916, the American producer Raoul Barré was able to release upwards of *forty* installments of the *Mutt and Jeff* series, a number all of the Soviet animation studios combined did not match once in the years 1918 to 1935. The answer, of course, was cel animation. The creation of a Soviet cartoon star required not only a character as dynamic as Mickey Mouse but also a studio "as truly of the machine age as Henry Ford's plant."[17] With the help of Lucille Cramer of Fleischer Studios, the Russian animator Viktor Smirnov finally introduced the cel animation technique in the mid-thirties, a full twenty years after the first patent was approved in the United States. The Soviet Mickey Mouse was to be Yozh, a hedgehog in shorts and suspenders, who starred in Smirnov's *U sinia moria* (*By the Blue Sea*, 1935) and, as an article in the *New York Times* noted, owed his "existence to the American influence on Russian film production"—an influence with implications for the organization of labor and the basic materials of film production, as well as visual style and storytelling.[18]

The mid-1930s thus proved to be a critical turning point in the history of Russian animation. Following the implementation of the socialist realist style, projects long in development were subject to censorship, including a collaboration between Dmitri Shostakovich and Tsekhanovsky; some animators, such as Nikolai Khodataev, unwilling to abandon the techniques they had been practicing for over a decade in favor of the new assembly-line model, decided to leave animation altogether; and, by 1936, animation production in the country would be consolidated within a single studio, initially called Soyuzdetmultfilm (Union of Children's Animation), a name that reflected a calculated effort to position animation as children's entertainment first and foremost. Tsekhanovsky adopted cel animation, as well as the technique of "éclair," or rotoscoping, in which live-action cinematography is traced frame by frame. His films of the forties and fifties are populated by human figures that bear an uncanny resemblance to the flesh-and-blood actors who served as their models; rotoscoping, which was designed to allow more "naturalistic" movement, in fact yielded an unsettling stiffness, as animators too closely conformed to the contours they traced. In a series of lectures from 1970s, the animator Ivan Ivanov-Vano, a contemporary of Tsekhanovsky, contrasted the literalness of Tsekhanovsky's rotoscoped characters with the plasmaticness of free drawing; a rotoscoped drawing was bound to its referent, whereas even the roughest of doodles had the potential to become anything at all.[19] The worst excesses of the American style had won—but it was now a style that had no ideas, let alone gags, of its own. It was merely a pale vestige of conventional cinematography. Eisenstein bemoaned this, noting in the late 1940s that Russian animation was neither sufficiently Russian nor sufficiently animated.[20] It wasn't until the 1960s, over three decades after the release of *Pochta*, that Russian animation recovered the promise of Tsekhanovsky's masterwork. Films such as Fyodor Khitruk's *Istoriia odnogo prestupleniia* (*Story of One Crime*, 1962) and *Fil'm, Fil'm, Fil'm* (1968) (which features a caricature of Eisenstein, no less), Ivanov-Vano's *Levsha* (*Lefty*, 1964), and Andrei Khrzhanovsky's *Stekliannaia garmonika* (*Glass Harmonica*, 1968) returned to the cutout techniques and bold graphic design of *Pochta* in combination with the very dark satirical edge Tsekhanovsky had, at one time, sought.

It is impossible to watch *Pochta* and not to think about the *what ifs*. What if the cel animation technique, let alone socialist realism, had not been implemented in the Soviet Union? Or what if the demand had been for an

American *Pochta*, not a Soviet Mickey Mouse? *Pochta* is a stunning film in its own right, but it is no less powerful for its potential—the paths it breaks, which no one else followed or could follow. Even Tsekhanovsky's own 1964 remake of *Pochta* cannot compete with the visual style of its predecessor; the cel animation technique dooms its poodles and little boys and butterflies to cutesiness. For a viewer invested in the avant-garde possibilities of animation, mid-century animation is the epitome of kitsch. In this same period, the plasmaticness of Disney was giving way to a brand of realism that many of his early champions found distasteful. Manny Farber, who thought that the *Mickey Mouse* cartoons, by untethering its world from our own, were "perfectly suited to a moving camera," had nothing but vitriol for what he saw as the "bogus art" of *Bambi* (1942)—its vulgar colors, its "affectation of reality," its prettiness.[21]

There is, however, another way of conceiving of *Pochta* and its relationship to both Soviet and American animation—and this is not to look at what came after it as an irreparable break. The story of Tsekhanovsky, which I have only sketched here, is tragic. It is a story of state censorship, of artistic compromise, of necessary surrender. The potential of *Pochta did* go unfulfilled. Yet there are other ways to fulfill its potential, and that is by seeking out continuities between the film and those that followed it—moments, even just slivers of a second, in which animators of the period, whether they knew it or not, rose to *Pochta*'s challenge. *Pochta*, I argue, contains within it unwritten histories, which enable us to recover mysteries and magic latent within even the putatively "realist" aesthetics of mid-century American and Soviet animation.

The storm scene in *Pochta*, a scene that is perhaps its most visceral and thrilling, provides one such point of contact between Tsekhanovsky's work and other animated films. Similar scenes abound in American cartoons of the 1930s and beyond—from Disney's *King Neptune* (1932) and Ub Iwerks's *Stormy Seas* (1932) to Max Fleischer's *Gulliver's Travels* (1939) and Disney's *Melody Time* (1948) and *So Dear to My Heart* (1949), and onward to *The Little Mermaid* (1989), *Pocahontas* (1995), and *Tarzan* (1999). The animation of water—its ripples, its reflections, its currents—is among the most difficult of tasks, such that Disney had an entire department devoted to it alone. How can a cartoon do justice to the sea's fickleness and sublimity? Instead of shy away from this challenge, however, animators tackled it head on. They studied slow-motion film of the churning ocean, they tested out their ideas in oil paint

Pinocchio, 1940.

and colored pencil—and then they turned away from representation altogether, opting instead for abstraction. When Monstro the whale pursues Geppetto and Pinocchio in *Pinocchio* (1940) across an ocean he has made rage, the frame periodically fills with pure color. Tiny strokes of white foam cover the screen like frost on a windowpane; the strips of blue (azure, cobalt, turquoise, cerulean) that are sky, sea, and whale provide a flat ground against which these cascades of silver and gray erupt. A reviewer for the *Chicago Daily News*, who saw only a test version of this sequence, claimed it rivaled the work of Picasso and Braque in its combination of abstraction and representation, two-dimensional line and three-dimensional volume: the animators had captured the storm's essence.[22] There is no reason, of course, to believe that *Pochta* influenced *Pinocchio*—after all, since at least Winsor McCay's *Sinking of the Lusitania* (1918), animators have struggled to bring the ocean to the screen. Rather, *Pochta* offers a key locus in a genealogy of water effects and storm effects; it is through *Pochta* that we can learn to begin to rewrite the history of the aesthetics of animation.

For example, it is very easy to dismiss, if not altogether forget, Fleischer's *Gulliver's Travels*. The film is undoubtedly marred by the rotoscoping of its main character, who seems never quite at ease among the decidedly cartoonish Lilliputs; we recoil at his stiffness and awkwardness in these scenes, just as we recoil at the animated cartoons Tsekhanovsky directed in the forties and fifties. But *Pochta* prompts us to look again, and to look closely. The film opens with a storm at sea, one that combines abstract patterns of water in shades of purple and green with stroboscopic effects. The latter is accomplished much as it is in *Pochta*, through the rapid alternation of frames. In *Pochta*, these frames consist of positive and negative

Felix Dines and Pines, 1927.

versions of the same image (e.g., a white ship against a black sky, a black ship against a white sky). In *Gulliver's Travels*, meanwhile, an additional cel is overlaid on the already busy abstract composition; in place of the purples and greens are tans and baby blues. The staggering of these not quite complementary colors suggests a blinding, fleeting blast of lightning.

 Pochta did not pioneer stroboscopic effects. Examples run through Otto Messmer's *Felix the Cat* cartoons of the 1920s, which routinely featured brief "flicker" sequences meant to elicit the sort of somatic overload brought on by violent shock. Moreover, *Felix the Cat*, too, frequently evokes the optical pulsations of Duchamp's rotoreliefs or Bentham's top, much like the train sequence in *Pochta*. In *Felix Dines and Pines* (1927), for instance, Felix runs through a hallucinatory series of concentric circles. If Harry Potamkin had his way, we would dismiss *Felix* as but another iteration of "the cult of the child."[23] But *Pochta* focuses our attention.

 Even Tsekhanovsky's later films warrant renewed scrutiny. Consider *Tsvetik-semitsvetik* (*Flower of Seven Colors*, 1948), which features a girl whose design exemplifies the kitschiest excesses of socialist realism—cheeks so delicately blushed, lips as red as her dress, eyelashes as finely and precisely delineated as the bows in her hair. If *Bambi* is vulgar, then there is no word to describe *Tsvetik-semitsvetik*. We cringe. We want to look away. But we shouldn't, as *Pochta* reveals. A dog steals the girl's biscuits, and she chases after him. At first she moves laterally across a static background, this way and that. Then she turns a corner, and the film turns with her. The entire background is animated. As she moves through it, the world rotates to reveal new sides, new dimensions. She runs toward the camera, and the world falls away behind her. In a subsequent shot, we see the world from her perspective. Towering evergreens give way to blossoming arches, apple

Tsvetik-semitsvetik (Flower of Seven Colors), 1948.

trees give way to overgrown hedges. One shape swells effortlessly into another. The world, for just a few seconds, is plasmatic. The elasticity of cel animation, in which anything can become anything, meets the seething seas of *Pochta*, into which the viewer plummets headlong. This is the ultimate possibility held out by *Pochta*. At any moment, we sense, even the stiffest of characters can take off running—and we, and the world, might very well take off alongside her.

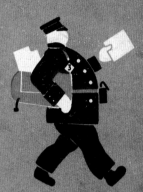

1931

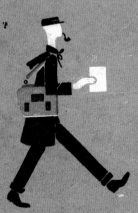

Типография „Печатны

Д.-68. Огиз № 599/л. Ленинградский

NOTES

1. Harry Potamkin, "Film Cults," *Modern Thinker and Author's Review* (November 1932), reprinted in *Compound Cinema: The Film Writings of Harry Alan Potamkin*, ed. Lewis Jacobs (New York: Columbia University Press, 1977), p. 230.

2. See Potamkin, "Light and Shade in the Soviet Cinema," *Theater Guild Magazine* (July 1930), reprinted in *Compound Cinema*, 313–17; Potamkin, "The New Kino," *Close Up* (March 1931): 64–70.

3. Potamkin, "Light and Shade in the Soviet Cinema," p. 317.

4. Ibid.

5. Potamkin, "The New Kino," p. 70.

6. See Walt Disney, "Growing Pains," *Journal of the Society of Motion Picture Engineers* (January 1941): 36–37.

7. Potamkin, "The New Kino," 70; Sergei Eisenstein, *Nonindifferent Nature*, trans. Herbert Marshall (Cambridge: Cambridge University Press, 1987), p. 389.

8. Walter Benjamin, "Mickey Mouse" (1931), in *The Work of Art in the Age of Its Mechanical Reproducibility and Other Writings on Media*, trans. Rodney Livingston (Cambridge, MA: Harvard University Press, 2008), p. 338.

9. Sergei Eisenstein, *Eisenstein on Disney*, trans. Alan Upchurch and ed. Jay Leyda (London: Methuen, 1988), p. 21.

10. Mikhail Tsekhanovskii, "Dykhanie voli: Dnevnii Mikhaila Tsekhanovskogo," *Kinovedcheskie zapiski* 57 (2002): 345. All translations of passages from Russian texts are, unless otherwise noted, my own.

11. Adrian Piotrovskii, "Kinomul'tiplikatsiia," *Zhizn' iskusstva* 17 (April 21,1928): 9.

12. Mikhail Tsekhanovskii, "Ot 'murzilki' k bol'shomu iskusstvu," *Sovetskoe kino* 10 (1934): 26.

13. Tsekhanovskii, "Dykhanie voli," p. 299.

14. Potamkin, "Film Cults," p. 231.

15. I cannot help but recall Eisenstein's description of Jean Cocteau's handwriting: "The writing looked like drawings, or lacework. Lines crawled over the page like caterpillars, heading in different directions." Eisenstein, *Beyond the Stars: The Memoirs of Sergei Eisenstein*, ed. Richard Taylor, trans. William Powell (London: British Film Institute, 1995), p. 240.

16. Laura Pontieri, *Soviet Animation and the Thaw of the 1960s: Not Only for Children* (Bloomington, IN: Indiana University Press, 2012).

17. "The Big Bad Wolf," *Fortune* (November 1934): 88.

18. "A Russian Mickey," *New York Times* (June 10, 1934).

19. See I. P. Ivanov-Vano, *Mult'plakatsiia vchera i seogodnia*, 4 vols. (VGIK: Moscow, 1974–77).

20. Sergei Eisenstein, "Viatskaia loshadka" (1947/8), *Izbrannie proizvedeniia* vol. 3, ed. L.A. Ilina (Iskusstvo: Moscow, 1964), p. 500.

21. Manny Farber, "Saccharine Symphony," *New Republic* 106 (June 29, 1942): 893–94.

22. Quoted in "The True Abstract," *Art Digest* 13.20 (September 1, 1939): 23.

23. Potamkin, "Film Cults," p. 231.

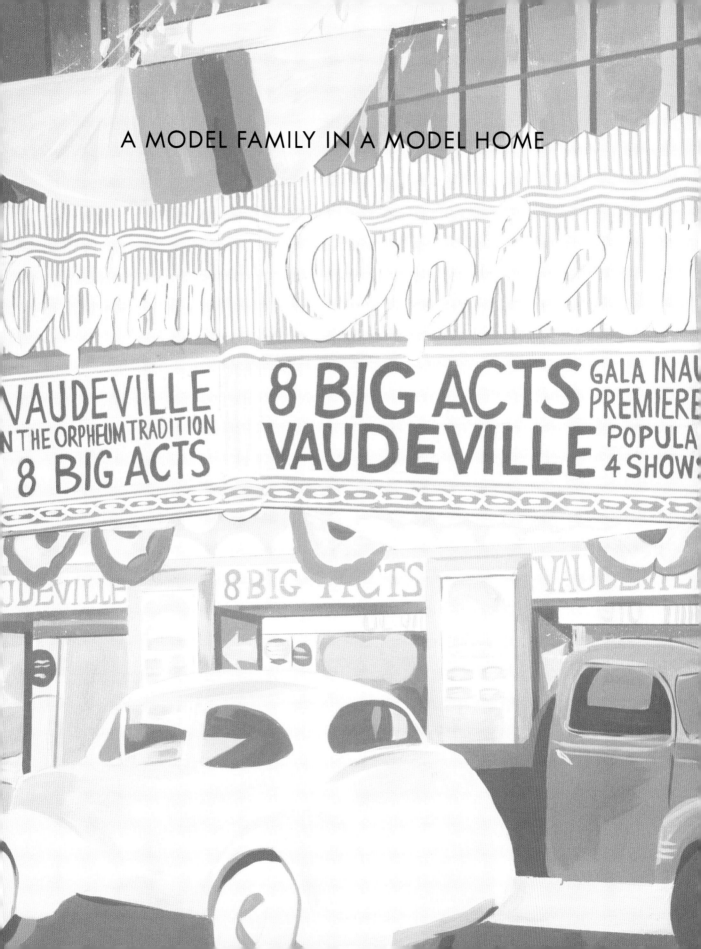

A MODEL FAMILY

a picture of wreckage: a living room in a shambles, lawyer's
letter concerning divorce, a tattered woman's hat.
headline: a model family home.

the family is sought from among 80 not ruled out. . . .

the afternoon before the exhibition opening, a quarrel
over an error. man

Opposite: Bertolt Brecht, A MODEL FAMILY, notes for a film, 1941.
Translation by Laura Lindgren.

Pages 116–19: "A Model Family in a Model Home," Life, September 15, 1941.
Photographs pages 116, 118, 119 by Alfred Eisenstaedt.

A MODEL FAMILIY

ein bild der zerstörung: zetrümmertes wohnzimmer, bri
ef eines anwalts über scheidung, zerfetzter frauenhut.
überschrift: a model family home.

man sucht die familie unter 8o familien aus. was allle
s nicht in betracht kommt....

am vorabend der ausstellungseröffnung ein krach, bez
ein irrtum. mann

A MODEL FAMILY
IN A MODEL HOME

The Frank Engels, chosen as "Ohio's most typical farm family," go on exhibition at State Fair

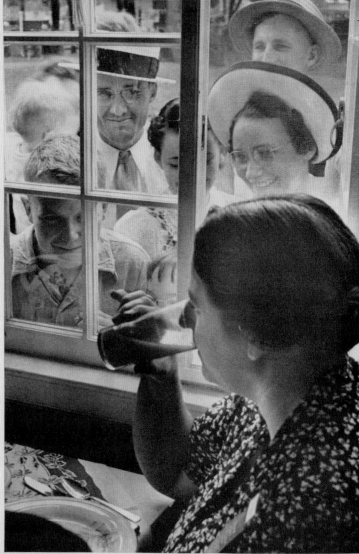

For a week from Aug. 23–29 Mr. and Mrs. Frank Engel of Berlin, Ohio, lived with their three children in a model home at the State Fair grounds in Columbus. The little white house in which they dwelt was equipped with every modern convenience. It lacked however, one traditional and highly important element of home life. It lacked privacy. From 10 in the morning till 10 at night the Engels attended to their chores, ate their meals and entertained themselves beneath the curious and amused scrutiny of thousands of strange eyes. For them, the mere business of living was like a domestic strip tease.

Nevertheless, the Frank Engels did not complain. They had been selected as "Ohio's Most Typical Farm Family" in a contest run by the Columbus *Dispatch*. Eligible were families operating farms of 50 acres or more, owned or rented. Local boards chose county candidates. And from 88 finalists the Frank Engels were chosen. Their reward: a week at the fair, with maid service, an automobile and chauffeur, free food, and infinite opportunity for self-expression.

Mr. Engel's own domain is a 144-acre poultry farm and hatchery 90 miles northeast of Columbus. His wife is pianist for the local Grange. Daughter Mary, 16, is a senior in high school and president of her 4-H Club. Son Dean, 11, wants to be a dirt farmer. Son Wayne, 9, is contemplating aviation. During their first few days the Frank Engels arose, according to habit, at 5:30 a.m. But the 205,296 inquisitive eyes that peered in their windows nightly kept them from their beds. By week's end the five enervated Engels guiltily found themselves sleeping till the slovenly hour of 7. Treat of the week for the boys was an airplane ride to Dayton. Treat of the week for Mary was meeting Bandmaster Horace Heidt. Treat of the week for Mrs. Engel was returning home and pulling down the blinds.

MRS. FRANK ENGEL, MODEL FARM WIFE, SIPS A BREAKFAST BEAKER OF TOMATO JUICE WHILE THOUSANDS PEER

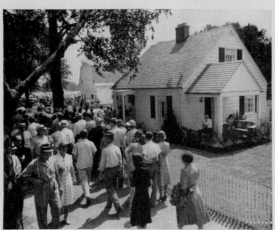

VISITORS WAIT IN QUEUES TO ENTER THE ENGELS' PUBLIC DOMICILE AT THE STATE FAIR

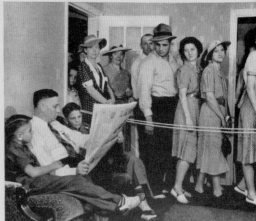

MR. ENGEL TRIES TO CONCENTRATE WHILE THE U. S. PUBLIC FILES THROUGH HIS P...

We're ready to give our answers quick
On readin' and writin' and 'rithmetic;
And it helps a lot, we have a hunch,
If we have Campbell's Soup for lunch!

OOD HOT SOUP *makes* A SCHOOLDAY LUNCH!

LOOK FOR THE RED-AND-WHITE LABEL

CAMPBELL'S VEGETABLE SOUP, with its 15 vegetables and bracing beef stock, is almost a meal in itself. A grand help on busy days! The children like it, and it's good for them, because it's easily digested and supplies needed vitamins and minerals. Here's a simple, satisfying lunch—

Campbell's Vegetable Soup
Cracker and Cheese Sandwiches
Sliced Egg Salad
Mixed Fresh Fruit Milk

CAMPBELL'S TOMATO SOUP, made of luscious tomatoes and fine table butter, is a youngsters' favorite . . . Dietitians urge hot food, such as soup, for children's lunches. Follow this advice and include a vacuum bottle of Campbell's Tomato Soup in the lunch box. Here's an easily fixed lunch the children will be sure to enjoy—

Campbell's Tomato Soup
Peanut Butter and Bacon Sandwiches
Apple and Cookies

Lunch at Home

Lunch at School

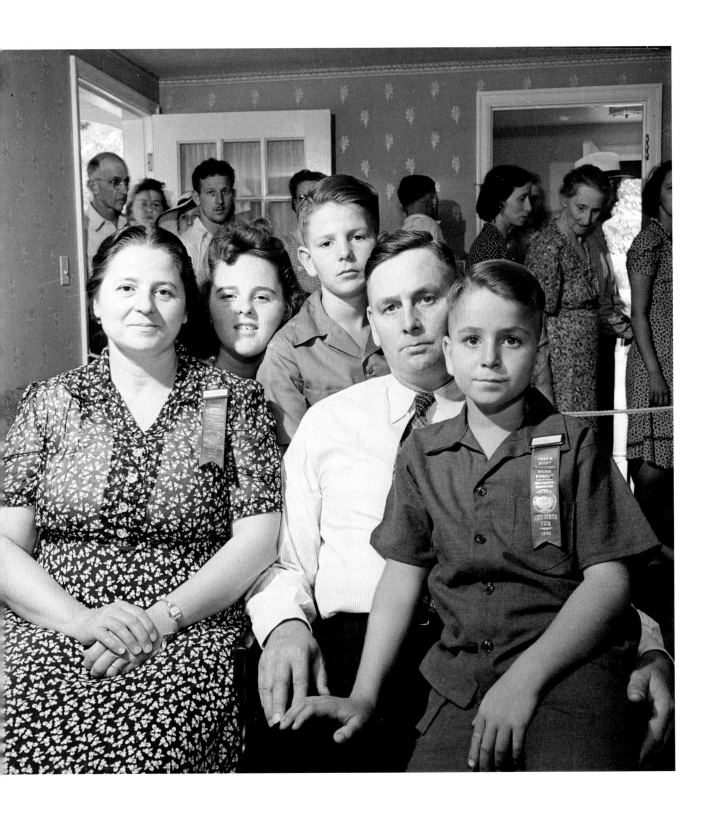

119

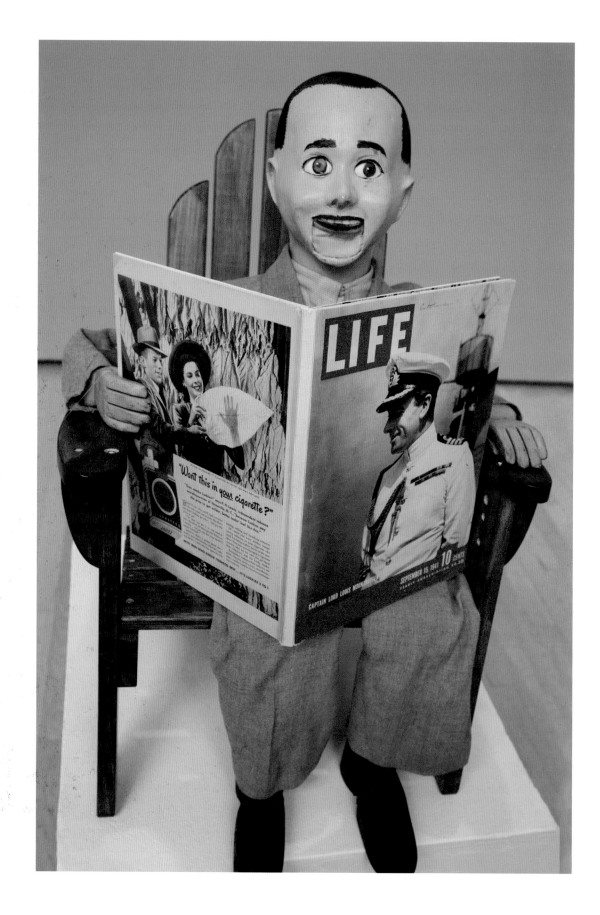

A MODEL FAMILY IN A MODEL HOME

2015

Written and directed by Zoe Beloff inspired by Bertolt Brecht's notes
for a movie to be titled *A Model Family*
Cinematography by Eric Muzzy
Voice-overs: Vladimir Weigl (Bertolt Brecht)
and Anthony Wellman (radio announcer)
Music composed by Hanns Eisler, arranged with new lyrics by Hannah Tempel
For a complete list of sources, see p. 131.
The film can be viewed at http://aworldredrawn.com

PROLOGUE
BERTOLT BRECHT BEFORE THE COMMITTEE ON
UN-AMERICAN ACTIVITIES

INT. HOUSE UN-AMERICAN ACTIVITIES COMMITTEE

Eric Bentley (V.O.)
Between the twentieth and thirtieth of October 1947 the committee on
un-American activities of the House of Representatives held some hearings
quote on the communist infiltration of the motion picture industry end quote.

One group of witnesses spoke against communism and named persons in
Hollywood whom they regarded as communists. The others pleaded the Fifth
Amendment and claimed that the investigation was improper. The witness
who stood furthest apart from the others was Bertolt Brecht whose testimony
you are now about to hear.

J. Parnell Thomas
Now Mr. Brecht what is your occupation?

Brecht
I am a playwright and a poet.

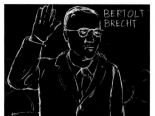

J. Parnell Thomas

Playwright and poet.

Brecht

Ja.

J. Parnell Thomas

Were you ever employed in the motion picture industry?

Brecht

Ja, I, ja, I sold a story to a Hollywood firm, "Hangmen Also Die," but I did not write the screenplay myself. I am not a professional screenplay writer. I wrote another story for a Hollywood firm but that story was not produced.

PART 1 BERTOLT BRECHT IN LOS ANGELES

EXT. LOS ANGELES IN THE 1940s

Narrator

Driven from his home in Berlin by the Nazis, Bertolt Brecht arrived in Los Angeles on July 21, 1941.

While war rages across Europe and the Soviet Union, he finds himself in the most advanced outpost of capitalism.

He writes a poem about it.

Brecht

In Hell too
There are, I've no doubt, these luxuriant gardens
With flowers as big as trees, which of course wither
Unhesitatingly if not nourished with very expensive water. And
Fruit markets
With great heaps of fruit, albeit having
Neither smell nor taste. And endless processions of cars
Lighter than their own shadows, faster than
Mad thoughts, gleaming vehicles in which
Cheerful looking people come from nowhere and are nowhere bound.
And houses, built for happy people, therefore standing empty
Even when lived in.

The houses in Hell, too, are not all ugly.
But the fear of being thrown onto the street
Wears down the inhabitants of the villas no less than
The inhabitants of the shanty towns.

Narrator

He must find a way to make a living for himself and his family. There is only one business in this town that he knows, writing. Here everyone writes screenplays and tries to sell them to the studios.

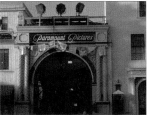

Brecht

Custom here requires that you try to sell everything, from a shrug of the shoulders to an idea.

 The landscape here lies behind plate glass and involuntarily I look for a little price tag on this chain of hills or that lemon tree. I also look for the price tag on people....

EXT. WORLD WAR II FIGHTER PLANE SHOT DOWN

INT. THE HOUSE UN-AMERICAN ACTIVITIES COMMITTEE

J. Parnell Thomas

Mr. Brecht, is it true that you have written a number of very revolutionary poems, plays, and other writings?

(Map of Allied armies advancing on Germany.)

Brecht

I have written a number of poems and songs and plays in the fight against Hitler and of course they can be considered as revolutionary cos, I, cos I was for the overthrow of that government.

PART 2 RECONSTRUCTION

Narrator

After the HUAC hearings were over Brecht left the United States forever, with many projects still unfinished, including fifty film treatments.

 Now it is up to us to begin the work of reconstruction.

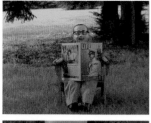

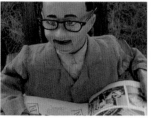

EXT. GARDEN. BERTOLT BRECHT (A VENTRILOQUIST'S DOLL) READS *LIFE* MAGAZINE

Narrator
1941. Searching for a subject that everyone understands Brecht avidly reads *Life*.

Brecht
An audience isn't just a million eyeballs, an audience is a collection of people with a desire to improve the world, watching a report about the world. I will give them something to think about.

Narrator
A story catches his eye, "A Model Family in a Model Home."

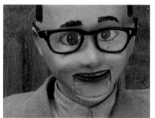

Radio Announcer
All you farmers out there, the *Columbus Dispatch*, right here in Columbus, Ohio, is running a competition for "Ohio's most typical farm family." Families operating farms of fifty acres or more, owned or rented, are eligible. The reward: one full week at the state fair in a model home equipped with every modern convenience including a maid service and a chauffeur.

Brecht
It will lack only one traditional and highly important element of home life. Privacy. From ten in the morning to ten at night it will be open to the public.

EXT. A FARM IN OHIO, 1941

Brecht (typing)
The model family.
First the search.
One family out of 80 is chosen.
What is left out?

Narrator
Brecht must learn everything about the American farm family. He is fascinated by the lives of working people. He studies them closely so that he can show the actors how to represent them.

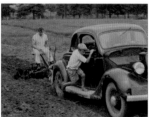

EXT. WORLD WAR II FIGHTER PLANES

INT. LIVING ROOM, A SERIES OF PEOPLE POSE FOR THE CAMERA

Narrator
Brecht will cast amateurs as well as professionals.

Brecht
How to behave in front of the camera, how to project the text is something that can be taught. I want to show that interestingness of the actor depends on the interest he brings to the social phenomena that he is concerned with in his acting.

The audience watching people like themselves can judge the American family rationally and impartially.

(A series of photographs of the model family in the model home taken by Alfred Eisenstaedt at the Ohio State Fair.)

A newspaper report is the best model for dialogue and dramatic action. Instead of pretending that something is happening in the present tense, the actor must visibly reproduce something from the past.

Actors will perform members of the Frank Engles family. They must make it clear that this family has been taken from their land and placed inside a new model home at the state fair.

Now instead of working the fields, their daily task is to perform "Ohio's Typical Farm Family."

The actors must show how the family slowly discovers that they are not actually honored guests at the state fair. No. They are working and their job is to sell the model home and all the merchandise inside. They are living advertisements for the companies: "Ken Dick Low Cost Homes" and "Doddington Lumber" who construct the home. "Cussins and Fearn" who furnish the home—as the Americans say, "lock stock and barrel." I will make sure people see this.

Alfred Eisenstaedt, staff photographer for *Life* magazine, poses the family in more than fifty different shots. This too will I include in my film.

EXT. GARDEN. BERTOLT BRECHT (A VENTRILOQUIST'S DOLL) LOOKS AT A MODEL OF THE MODEL HOME

Brecht

Day after day the family performs without being paid...long lonely hours surrounded on all sides by staring eyes...fifteen hundred visitors an hour overwhelm them...they can no longer keep up the illusion of a happy farm family.

For the first time they do not follow the script. They break the rules. They cannot, they will not, play the role of model family. They tear off their blue ribbons, the same ones awarded to prize livestock. In an act of desperation they turn on the model home where everything is for sale.

From wreckage can something new begin.

Yes! A battlefield...everyone runs amok.

A scene of destruction: a demolished living room, a letter from a divorce lawyer, a frazzled lady's hat.

PART 3 SPECULATION

Narrator

After Brecht returned to Berlin, Ohio's farm families faced a choice of two possible models of home construction. They could have chosen a cooperative form based on workers' cooperative housing in towns and cities or the rural electrical cooperatives springing up all across the country.

SOCIALISM

NATIONAL RURAL ELECTRIC COOPERATIVE ASSOCIATION PRESENTS

BY THE PEOPLE FOR THE PEOPLE

INT. FARMERS ATTEND A COMMUNITY MEETING

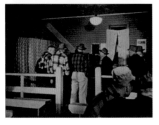

Narrator

In 1935 a rural electrification program was provided for by executive order signed by President Roosevelt. All over America farmers gathered in neighborhood meetings to discuss ways and means of putting this new idea to work. For many it was just what they had been waiting for but for some it

appeared impractical or even impossible.

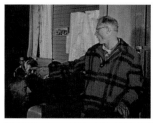

Tom

You Joe, what do you know about stringing up a wire, and Bill, do you think you could ever make it to the top of the light pole?

(laughter)

No sir. I have my doubts about that.

Bill

Tom says I can't climb a power pole. I guess he's right. But that won't keep me from getting electricity. I think us farmers can do anything we set our minds to, if we do it together.

Narrator

So America's rural electric systems were born. In true democratic fashion farmers elected their own directors and officers. They signed up as members because they had faith in cooperation as a practical way to get things done.

EXT. SCENES OF FARM LIFE WITH ELECTRICITY: ELECTRIC LIGHTS IN THE FARMHOUSE, ELECTRIC IRON, FARM MACHINERY, MILKING MACHINERY

The great moment had come, electric lights began to go on all over rural America. In the home and in the farm yard electricity began to help the farmer.

INT. MEETING OF THE CLK-BURNETT ELECTRIC COOPERATIVE

But having electricity is just the beginning. Just owning a rural electric system is not enough. Farmers know that active participation is the lifeblood of any democratic member-owned organization. They must attend their membership meetings where issues are debated, responsible directors are elected, where decisions are made that will keep their organization strong and progressive.

OR CAPITALISM?

OR CAPITALISM?

Narrator

Or was the model home at the state fair a harbinger of things to come?
A capitalist future fueled by developers selling the public a fantasy of life
depicted in the motion pictures of Hollywood...impossibly idealized model
families in model homes.

HOMES UNLIMITED

A TALE OF AMERICAN FREE ENTERPRISE

PRESENTED BY THE NATIONAL HOMES CORP.

INT. REAL ESTATE OFFICE. A COUPLE LOOKS AT PHOTOGRAPHS OF
MODEL HOMES

INT. FACTORY WHERE PREFABRICATED HOMES ARE ASSEMBLED

EXT. A PREFABRICATED HOUSE IS ASSEMBLED

Male Narrator

Throughout the nation today, thousands of attractive new communities with
bright houses of modern design are being built to fulfill a dream that less
than a generation ago was difficult to realize, for house ownership required
an initial investment and monthly payments far too steep for eighty percent
of the country's families. The desire of Americans to own their own homes is
one of the most compelling in our social and economic life.

INT. NEW HOME

Male Narrator

Today for the first time this limitless demand can be met.

Housewife

We were proud of this clean airy design and of the warmth and charm given
the living room by the use of distinctive colors.

EXT. VIEWS OF A VARIETY OF SUBURBAN HOMES

Male Narrator

Homes mean a prosperous community because their owners, whatever their incomes, spend a good part of it in the local stores, pay their share of the taxes, and put aside as much as they can in the local banks and savings institutions. Homes mean a better community. For all these reasons and many more, for a great new opportunity for America, there must be homes unlimited.

PART 4 FICTITIOUS CAPITAL

EXT. SHOPPING MALL, WENTZVILLE, MISSOURI

Narrator

The capitalist model homes have not only use value but exchange value. Home ownership becomes a form of savings for the people in them, an asset. But the past thirty or forty years home ownership has become a form of speculation.

Today, in the twenty-first century, finance has evolved. Today's model home is constructed with nothing more than what Marx called fictitious capital.

EXT. SUBDIVISIONS, RURAL MISSOURI

The credit system manages production and demand. The banks fund the developers to build the subdivisions. The developers need a market so the financiers lend money to families to buy their houses.

And because they regulate supply and demand they can also manipulate prices. And if no one can afford the houses the bankers say, "Instead of 20 percent down, how about 10 percent down and then 100 percent financing." They make their money out of fees and don't care about the mortgage.

In 2008 the exchange value of homes blows up. Ordinary people lose upwards of forty billion dollars in assets. Six million lose their homes.

The financiers collect their bonuses.

If Brecht wrote the song of supply and demand today it might go like this:

(singer accompanied by accordion)

Who lends money for houses?
Who lends money to build those houses?

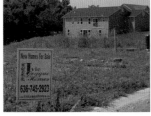

The people need homes
If I lend low to buyers and builders
Then I can drive demand up
Even those who can't afford it
Will receive a mortgage
For me their mortgages will turn a profit

What is a mortgage actually?
Do I know, do you know
Don't ask me my advice
God only knows what a mortgage is
I only know its price.

The market makes it efficient
I found a way there's nothing to lose
The risk has all been traded
Eager buyers took on debt
That debt's been sold and bundled
If these homes are all foreclosed on
It will not affect me
There are far too few homes anyway

What is a home, actually?
Do I know, do you know,
Don't ask me my advice
God only knows what a home is
I only know its price

I don't know what a home is
I only know its price.

SOURCES

Authors unknown. 16mm home movies, Ohio, 1939. Collection Zoe Beloff.

Brecht, Bertolt. *Bertolt Brecht before the House Un-American Activities Committee: An Historical Encounter, Presented by Eric Bentley.* Folkways Records FW05531 / FD 5531, 2004.

———. *Bertolt Brecht Poems Part Three 1938–1956.* Edited by John Willett and Ralph Manheim. London: Eyre Methuen, 1976.

———. *Journals 1934–1955.* Edited by John Willett. Translated by Hugh Rorrison. London: Bloomsbury Methuen Drama, 1993.

———. Unpublished notes, Bertolt Brecht Archiv, Berlin.

Harvey, David. Lectures. http://davidharvey.org.

Life magazine, September 15, 1941.

National Homes Corporation. *Homes Unlimited: A Tale of Free American Enterprise.* 16mm film.

National Rural Electrical Cooperative Association. *By the People for the People.* 16mm film.

The song "Supply and Demand" is based on "Angebot und Nachfrage" composed by Hanns Eisler for the Brecht play *The Measures Taken* arranged with new lyrics by Hannah Temple.

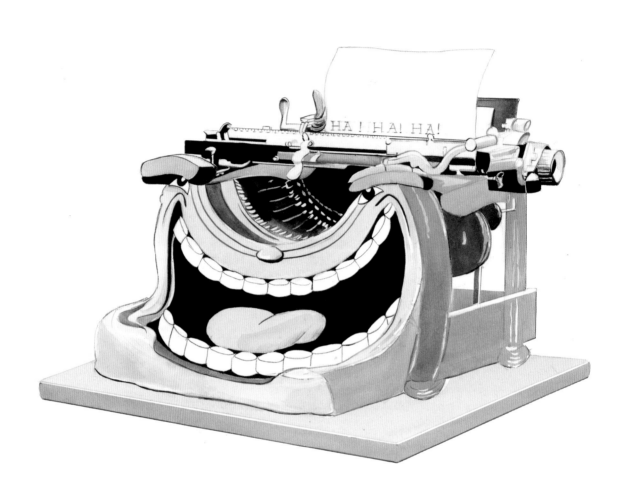

THOSE IN GLASS HOUSES LAUGH

Esther Leslie

HAR DE HAR

Laughter, in Walter Benjamin's words, is "shattered articulation."[1] Laughter breaks up both words and the body. Everything is disarticulated. A person in movement might be stopped in their tracks. A person speaking has the stream of words cut off. The listener hears only a clatter of stuttering sounds. Laughter is an interruption to the ongoingness of life and meaning. The flow of walking or talking is held up, stymied, while the disruptive event occurs. The body collapses in laughter, contorts and crumples, the face distends, the eyes close, the neck flips back, the arms and legs flail. Animation is often designed to induce laughter, but it also represents it. There are countless animated GIFS that loop a character's spasms while laughing, the arms clutching the chest, the mouth as wide as can be, the eyes crinkled shut, the explosions of noise. In some depictions, the eyebrows even leave the face and judder in a space above the head for a few moments. The body is outside itself or beside itself, beside itself with laughter.

Walter Benjamin's thoughts on the irruptive nature of laughter are surely in dialogue with the insistence of his friend Bertolt Brecht on pleasure in theatre (pleasure, discerns Brecht in note 2 of "A Short Organum for the Theatre," is "the noblest function that we have found for the 'theatre' "[2]). But his thoughts also follow Brecht's line that laughter is part of thinking, or specifically part of dialectical thinking. In fact, it is Brecht's character the physicist Ziffel, in *Refugee Conversations*, who observes this, while reflecting on the philosopher Hegel who, Ziffel insists, had "the makings of one of the greatest humorists among the philosophers."

> He had such a sense of humor that he was unable to think, for example, of order without disorder. It was obvious to him that the greatest disorder resides immediately in the vicinity of the greatest order. He went

Zoe Beloff, drawing after a still from *Ha Ha Ha*, a film by Dave Fleischer, 1934.

so far as to say: at one and the same place! He understood the state as something that comes into being where the sharpest antitheses between the classes appear. That is to say, the greatest harmony in the state lives off of the greatest disharmony of the classes. He disputed whether one equals one, not only because everything that exists passes inexorably and indefatigably over into something else, specifically its opposite, but because nothing at all is identical with itself. As is common to every humorist, he was particularly interested in what happens to things.[3]

Things are never identical to themselves through time. They decay. They grow. They break. They conspire against humans to bruise and bump them. They are one thing and then they are another. Things do not stay still. This is what Hegel observes. Hegel, according to Ziffel, recognises that everything contradicts itself. All peace and quiet is interrupted by explosions. And it is not just that things turn into other things for real. Things also undo themselves in thought. If a limit is imagined, then immediately the mind conceptualizes a beyond. The limit is negated. If a chair is imagined, then that chair in thought conjures up all the chairs it is not. It is itself but, at the same time, its existence is dependent on it not being something else. There is something absurd about this notion of being conceived as dependent on not-being. However, for Hegel, absurdity, error, and stupidity drive the dialectic forwards. If the dialectic moves forwards, that is because thinking and historical action are happening. The dialectic is a name for change and changeability. Something *is*, only to become in the next moment other to itself or exposed as dependent on its opposite, which threatens to collapse the stability of its self-identity. Hegel's concepts, notes Ziffel, "have always been rocking on a chair, which at first makes a particularly comfortable impression, until it falls over."[4] The chair collapses. The figure splays. The banana skin sends the man innocently and ignorantly walking along sky high and groundward. The gag is done. But thinking is not done with. With the joke, thinking is truly catapulted into motion. In "The Author as Producer," from 1934, Benjamin notes:

there is no better starting point for thought than laughter; speaking more precisely, spasms of the diaphragm generally offer better chances for thought than spasms of the soul.[5]

Laughter is shattered articulation, shattered words and shattered thoughts. And laughter shatters the body. The diaphragm writhes—and in so

doing undermines the rhetoric of the soul, with its penchant for identification and sentimentalism. As things break up or down, there is the opportunity to reflect on what they were and on what might replace them. Such breakage, coupled to an attitude of endless questioning and reflecting, with a humorous, sceptical, distanced mien, is annexed by Brecht to his own epic drama, and as Benjamin notes of this stripped down form: "Epic theatre is lavish only in the occasions it offers for laughter."[6] It produces laughter, or at least a giggle or a shrug, by breaking up the flow, by interruption, by slicing the narrative into scenes and the scenes into *Gestus*, stances, postures, which exemplify social attitudes and the conditions of their mutability. It breaks up the flow of what might be deemed unquestioned life by the technique of literarisation, a kind of footnoting by means of slogans or images, placards or projections, breaking up the coherence of the space, punctuating it, in order to comment internally on the action. Such is also the practice of Zoe Beloff in *The Days of the Commune*, which restages over a series of weekends with professional and nonprofessional actors Brecht's play *Days of the Commune* in one of the sites of Occupy Wall Street and other public spaces in New York. The film is literarised, in the sense that captions, signs, labels are used as part of its work of defamiliarisation. At the same time, drawing, another means of conveying and commenting on information, is key to the film. Beloff said of the use of drawing in the film, "I started thinking back to a time when drawing was really important, to Manet and Courbet drawing the events of the Paris Commune." Drawing relates to what is and what might be—and has its own relationship to laughter too, in the form of the comic strip, the gag, the cartoon. It needs to remain close at hand for irruptive, revolutionary practice.

Benjamin extends the thought on shattering of articulation to film and photography. If the body is interrupted and disrupted in laughter, the photograph too might be seen as an interruption—of time, of action. As such, it represents a shattering of the coherence of events, of the course of time. Photography and film crack things up. They do this by dislodging what is apprehended from its time and space, its here and now. Through reproduction, mechanical modes of representation shatter coherence, projecting a fragment of a moment into future time and other spaces. In severing the artistic conventions of originality and authorial creativity, film and photography contribute to "a shattering of tradition," as Walter Benjamin phrases it.[7] And they shatter too, or may shatter, appearance, in

order to reveal deeper, other, more essential forces at work in the world. The film camera may slice through the surface appearance of everyday life, as does a surgical instrument through skin. In so doing, it contravenes the tendency of film to glide over surfaces, forcing what is represented to become, in Benjamin's words, "manifold parts," which are "assembled according to a new law."[8] The world is "laid open,"[9] in order to be entered into, and viewers come away with an enhanced knowledge of the structure of actuality through exposure via the super-perceptive and analytical eye of the film camera. The world is as if of glass, shatterable. In being smashed, having passed through the glass of the camera, it releases meaning for us. The broken parts of recorded actuality are combined into new chains, or left fractured, by directors, editors, artists, by whoever works on the material of film. Disparate times and spaces are segued or montaged. Events run backwards. Never made encounters occur. Audiences penetrate other relationships between parts contained even in very ordinary reality, once it has been fractured into shards. It is through such work with shards, with disarticulations, that humour may emerge.

SPLITTING

"The splinter in your eye is the best magnifying glass," notes T. W. Adorno in *Minima Moralia*.[10] Adorno was a cultural critic and philosopher, best known for his negative perspective on popular cultural forms. His negativity extended, in fact, across the cultural spectrum and he was as dismayed by high culture's sclerotic veneration of classical forms as he was by the venal motives he perceived in culture for the masses, termed by him the "culture industry." For Adorno, genuine culture is motivated by a dialectical urge: to produce an anti-commodity, that is, to mark out something entirely other to culture as an entity congruent with modern capitalist business. But, at the same time, what is produced must commit to acknowledging within its form the current impossibility of escaping the insistent and pervasive force of commodity-society. For this reason, for Adorno, a certain pain has to accompany cultural reflection. Adorno's takes the shards of culture and turns them inwards, in a painful image of splinters in the eye. His image renders a slicing through not of the web of reality, but rather the mechanism of seeing. His motivation was the distrust of the invented mechanisms of vision, the glassy lenses that intensify, illuminate, expand vision, and provide the image maker with ever more sophisticated tools for illusion. The enlargement achieved by a standard magnifying glass brings back an increased quantity

of information. It enlarges details. It makes visible that which has not seen by the human eye before, or not in that way. It provides access to something, but this is not an expanded apprehension in any meaningful sense. The magnifying glass makes things bigger, but it does not necessarily allow the spectator any better access to the meaning of what is magnified. The splinter in your eye, which he advocates, is by contrast, a fragment of glass, a broken shard of lens that does not simply look outwards into the world, seeing objectively, viewing objectivity, bringing to sight the world through and behind a lens. This splinter does not give a view, as seen through a window, onto a stable world out there, transmitting this back into the viewing eye. Rather this splinter conducts between vision, eye, and world. It cuts into the eye that sees. It juts out into the world that is seen. It disrupts the body. It begins to shatter it. This splintered lens must cause pain, when it cuts into the eyeball, and, as such, in its eliciting of suffering, renders the viewer an involved spectator—or something much more than a spectator—of the scene. The viewer is affected by the scene, to the extent of being injured, if only metaphorically. In fact, the eye with the splinter in it cannot see, in the usual sense. In Adorno's aphorism, the flaw in vision becomes the route to vision. The magnifying glass that cuts into the eye enlarges the error that is the world—an erroneous state that is always present, but unseen in usual mechanisms of imagery. Only when directly interpolated—pronged—in the mechanism of vision by the mode of seeing, can we speak of authentic seeing. Sight, then, is insight—turning inwards into the self—but it is also insight into the conditions of seeing, into mediation. For Adorno, no sight can be accepted as true if there is no flaw included. A flaw in vision, a flaw in the machine, a flaw in what is seen in a world in which all is flawed. We are far from laughing. It is not side-splitting, rather it is eye-splitting. And yet the themes of seeing and sightlessness, knowing and obliviousness have lent themselves to a certain humour—within the genre of animation, for example, there are the hapless, and yet ever lucky, myopic Mr. Magoo.

Adorno's aphorism on the splinter indicated the extent to which the flaw in vision might be truthful, in a world that is false. This heads back to Hegel's notion of error on the route to truth, but it also evokes dada's sniggering play with art and anti-art. At the beginnings of modernism, art circles had been challenged by Marcel Duchamp's paradox of art, which hitched blindness to insight, in a mode that showed Duchamp to be consciously acting dumb. Duchamp was coeditor of a magazine called *The Blind Man*. In the issue of May 1917 he published an anonymous letter—probably

written by himself and Beatrice Wood—in support of his much-pilloried readymade *Fountain*, which had originated as a porcelain urinal. The letter was written apparently by a blind reader, who had not been able to see the controversial object, but nonetheless expressed "blind solidarity." The blind apparently "see" the readymade rather than the seeing being blinded by the readymade's refusal to return the spectator's gaze, in the way that the spectator expects, that is to say, its refusal to provide aesthetic pleasure. *Fountain* does not want to be seen by the seeing, because they see blindly. The blind see differently and in good faith.[11]

And the seeing see nothing, or rather they see but without knowing. They know not what they see and they see not what they know, but something that imitates it so effectively they might slip under its illusioning surface, and come up only for the cold air of reality, which they breathe uncomfortably until the next bath of tears and grins. At least that is how the critics of the culture industry characterized its workings, with Adorno at their helm. And his aggression towards that culture industry with its clichéd and ideologically driven outputs, its manipulative and artistically uninteresting swill, its, for him, oxymoronic culture as industry, is diverted into an aggression towards the self. The wounded self is wounded again. Perhaps this is some version of a Hegelian negation of the negation.

Critical filmmakers and other artists of the modern period sought ways of making the work of art something like a splinter in the eye. A disarticulation of art's parts was a first step to assessing art's possible critical qualities. In a protest against bad films, *Film Enemies of Today—Film Friends of Tomorrow*, written in 1929 as a manifesto for the Stuttgart *Film und Foto* exhibition, Hans Richter begins with the basics of cinematic form, outlining the twenty-four frames a second principle, then moves immediately into the tricks of slow-motion, speed-up, superimposition, lens distortion, animation. It is the camera as box of tricks that makes film a valid form for Richter. The camera as box of tricks leads the assault on naturalism. Richter asserts in radical antinaturalist fashion:

> It is the case, then, that the same is true of film as has long been proven with every other art form. To be bound to nature is a restriction.[12]

Yes, to be bound to nature is a restriction. But to be cut loose from it is no solution either. Here animation might step in. Animation partakes of nature, is wilful with it, and in so doing perhaps comes closer to something

that is within nature, an animating impulse, a drive to form and deform, and transform. The world and its workings are released from the grip of nature and inevitability. As this happens, what occurs is a working on nature, its shattering by animation, the shattering of its apparent laws, or the quest to establish new ones. The breaking of the law has something funny about it. And as Benjamin notes:

> The cracking open of natural teleology proceeds in accordance with the plan of humor.[13]

What nature has apparently laid in store for us is bucked by imagery that deifies any and all talk of things being the way they are. The quotation is preceded by a reference to the proximity of liberatory politics and caricature.

> Fourier's long-tailed men became the object of caricature, in 1849, with erotic drawings by Emy in *Le Rire*. For the purpose of elucidating the Fourierist extravagances, we may adduce the figure of Mickey Mouse, in which we find carried out, entirely in the spirit of Fourier's conceptions, the moral mobilisation of nature. Humour, here, puts politics to the test. Mickey Mouse shows how right Marx was to see in Fourier, above all else, a great humorist.[14]

Charles Fourier's projections, written in 1808, in the wake of the French Revolution, predicted a great defrosting, a liquefaction into Utopia, brought about by momentous changes in nature.[15] These include a warming of the earth. The stormy gales and hurricanes turn out to be a product of civilization. These ebb and more gentle winds blow, making sea voyages as safe as those by land. The moon dissolves in the Milky Way and is replaced by luminous satellites. The poles melt, cleansing the sea and the air. Mingling with fluid from the Northern Crown, a "boreal citric acid," the seas turn into "a kind of lemonade," which is drinkable and renders it unnecessary to provide ships with barrels of water. This lemonade aids in the evolution of new sea creatures, useful ones who will pull in ships and help in fisheries, while the sea monsters, for whom this new environment is inhospitable, are killed in one fell swoop. We might laugh a little cynically at those aspects that have come true in the wrong way and those we imagine never possible. And yet its vision of a world reformed is motivating politically—who would

not like to reach the further shores of Utopia—and makes for a good joke that might yet be illuminating.

SIDE SPLITTING

As many have argued, animation is the form in which its objects and images, drawn or modelled, are dislodged from the usual order, from the nature of things, and are motile, flexible, open to possibility, able to extend in any direction or undertake any action or none. The animated object is unnatural—or a-natural. It has its own movement, illegitimately, which in itself cracks open any natural teleology and any obedience to law, natural or otherwise. It is all this that is inherently humorous and draws laughter from viewers, just as they also struggle to make sense of the nonsense worlds. Animation's distinctive contribution relates less to its conventional definition as the "illusion of movement" and more the "movement of illusion," a dislodgment that exposes the illusions to which we are subject, even to the point of dispelling them. It throws into relief the conventions of viewing and logic that we mostly are expected to live with and by. It achieves this through the generation of "different nature" (Benjamin[16]), which is different because it is unlike ours, but not distinct from it. Animation echoes nature, but shatters its laws in its physics-defying restructuring of space, time, and matter. Animation proposes small worlds, each one bound by the newly devised laws of the animator. Eisenstein wrote of "non-indifferent nature" (Eisenstein).[17] Nature is not dead, but alive and humanlike in many regards. And, conversely, humans are a type of landscape. Animation, which makes such thoughts palpable, can itself be conceived as "non-indifferent nature" because it appeals to us humans, speaks across all that divides us, invites us into its particular small world for the duration of the show. Animation's small image worlds draw out certain deportments on the part of viewers, pushing them to be at least marginally attentive to the means of the image world unfurling before them, particularly as it compares to the world which they inhabit. Animation offers a vigorous unconstrained image world in which—like Sergei Eisenstein's dialectical cinema—there is a condensation of tensions that appeals cognitively to viewers. In thrusting the viewer from image to thought, from percept to concept, it replicates the gesture of thinking itself—such that viewers are bidden to meet the film in appropriating its odd otherness. In its imagining of hybrid and hyperbolic life-forms, the caricature mode—whether as caricature itself or as it plays out in animation or other comic forms— accesses a truer truth. Such depiction leaves the realms of realism in order to

speculate on inner states, on lives as they are felt, as well as on incipient lives, ones that might yet be lived or laughed at.

Eisenstein devised a category of "plasmaticness" to stress the originary shape-shifting potential of the animated, the way in which an object or image, drawn or modelled, strains beyond itself, could adopt potentially any form, thereby rescinding all back to a moment that evokes an originary future potential, beyond current constraints.[18] If we were once like this, we might yet be so again. Or different, but at least other to how we are. All this potential is condensed in us. Eisenstein saw in animation the origins of the self, of our selves, and he truly believed that through it we accessed something of our primitive states, our ecstatic inner beings that remained with us, under the layers of civilizational distortion. Disney cast intense oranges and shining blues out into what Eisenstein called the grey squares and prisons of city blocks.[19] Eisenstein seized on animation's provisionality, which is thrown out, utopianly, against the rigid inflexibilities of the capitalist world. He affirmed animation's ability to range in any direction or embark on any exploit. He saw there, in its ecstatic plasmaticness, the beginnings of time and the ends of things, and animation's most apt symbol was fire, which, observes Eisenstein, "is capable of most fully conveying the dream of a flowing diversity of forms."[20] There is something more to be gleaned from the image, from time and space, something which extends backwards, reaches forwards, as stretchy and squeezy as the rubber-hose figures of Disney.

And perhaps there is something of this desire for a kind of being within being and a seeing beyond seeing, seeing into, beyond conventional outlines in *The Glass House*, the film Eisenstein planned in response to a number of developments, including Fritz Lang's *Metropolis* (1927) and the glass architecture of Bruno Taut and Ludwig Mies van der Rohe, as well as the American skyscraper.[21] The desire manifests from the perspective of the camera. A central feature of this vertically conceived film was a camera that could move anywhere, upwards and downwards, inside and out, without impediment, perceiving objects that appeared to float in space, inside a building whose walls, ceilings, and floors were fully transparent. Optical effects using glass were to be deployed: smashing glass, frosted glass, reflected rippling water in glass. The glass of the camera lens was to be toyed with too. In one version of the plan, the camera was able to see everything that happens, unlike the human characters who are limited in their vision and unable to perceive cuckolding or the disparities between rich and poor. The extension of visions and perspectives, such that the viewers see

everything and in all ways, however, means that transparency becomes not a route to clear understanding, but rather a conduit of complexity. Images overlap. Unhindered eye lines dissolve the scene into flurry. Points of view are unprecedented and difficult to interpret. The veil of commodity fetishism is lifted. In this pure exposure things go wrong as much as they go right.

CRACKING UP

For Benjamin, cartoons reveal brutality in the everyday world, the domination by technology, the—admittedly exaggerated—fact that even our arms or legs might be stolen from us.[22] The power of these strips is that the audiences recognise their own life in them, in all their absurdity.[23] But in showing this they also work therapeutically, because they evoke laughter in the face of injustice, injustice and a rebuff of the way things are.

> Collective laughter is one such preemptive and healing outbreak of mass psychosis. The countless grotesque events consumed in films are a graphic indication of the dangers threatening mankind from the repressions implicit in civilization. American slapstick comedies and Disney films trigger a therapeutic release of unconscious energies.[24]

Something is shattered in laughing. Negativity escapes. It escapes from us, stops us exploding in rage and sorrow. This is curative, or at least protects the viewers in some way, until the tension builds again. And it will always build as long as we live in a violent world with violent social relations. We release this energy, and differently to the other energy releases that are compelled from us daily. The body that capital, our master, demands, is an elastic one. This body can be squeezed and stretched, for it is a key instrument of labour, animated by the machines that employ it and set its rhythms: "capital is not a fixed magnitude, but is a part of social wealth, elastic and constantly fluctuating with the division of fresh surplus-value into revenue and additional capital."[25] Capital too is elastic, according to Marx, or it acquires the elasticity of labour-power, science, and land. Animation makes a graphic rendition of this stretching, shrinking. A strip of animation by Walt Disney from 1928, *Plane Crazy*, opens with a scene of Taylorised labor. The demands of labour under new conditions of industrial working life apparently go so far as to insist that one of the workers, a dachshund, insert himself in the machine, coiling himself like an elastic band inside the plane's body in order to make it fly. The apparatus is brutal and it will also go out

of control, starting, then stopping, then unable to be stopped, as it becomes a vehicle of brutal interpersonal relations. The entire world—including a church spire—kowtows before this machine, as it whirrs through the sky. What can we do but laugh at this world redrawn into reality and into absurdity at one and the same time. And then mobilize against this world.

NOTES

1. Walter Benjamin, *The Arcades Project* (Cambridge, MA: Harvard University Press, 2005), p. 325.
2. The "Short Organum" is reproduced in Terry Eagleton, Drew Milne, eds., *Marxist Literary Criticism* (Oxford: Blackwell, 1996), p. 109.
3. Bertolt Brecht, *Flüchtlingsgespräche* (Frankfurt: Suhrkamp, 1968), p. 111.
4. Ibid.
5. Walter Benjamin, *Understanding Brecht* (London: Verso, 1998), p. 102.
6. Ibid.
7. Walter Benjamin, *The Work of Art in the Age of Its Technological Reproducibility, and Other Writings on Media* (Cambridge, MA: Harvard University Press, 2008), p. 22.
8. Ibid., p. 35.
9. Ibid., p. 329.
10. T. W. Adorno, *Minima Moralia: Reflections from Damaged Life* (London: Verso, 1978), p. 50.
11. See Marcel Duchamp, Henri-Pierre Roché, Beatrice Wood, *3 New York Dadas and the Blind Man* (London: Atlas Press, 2014).
12. Hans Richter, *Filmgegner von Heute—Filmfreunde von Morgen* (Zurich: Verlag Hans Rohr, 1968), p. 33.
13. Benjamin, *The Arcades Project*, p. 635.
14. Ibid.
15. Charles Fourier, *The Theory of the Four Movements* (Cambridge: Cambridge University Press, 1996), pp. 49–51.
16. Benjamin's phrase for this is *eine andere Natur*. It has been variously translated as "a different nature" and "another nature."
17. See S. M. Eisenstein, *Non-Indifferent Nature: Film and the Structure of Things* (Cambridge: Cambridge University Press, 1987). The phrase "non-indifferent nature" is to be found where Eisenstein found it: in Hegel. It occurs in his discussion of Chemism in paras 200–203 of the *Logic*, where it is crucial to a discussion of motion, transformation, and affinity in natural processes.
18. S. M. Eisenstein, *Eisenstein on Disney* (Calcutta: Seagull Press, 1986), p. 11.
19. Ibid., p. 3.
20. Ibid., p. 24.
21. See the discussion in Oksana Bulgakowa, *Sergei Eisenstein. Drei Utopien—Architekturentwürfe zur Filmtheorie* (Berlin: Potemkin Press, 1996), pp. 109–25.
22. Walter Benjamin, "On Mickey Mouse," *Selected Writings: 1931–1934*, vol. 2:2 (Cambridge, MA: Harvard University Press, 2005), p. 545.
23. Ibid.
24. Benjamin, *The Work of Art in the Age of Its Technological Reproducibility*, p. 38.
25. Karl Marx, *Capital, Volume One*, chap. 24, section 5.

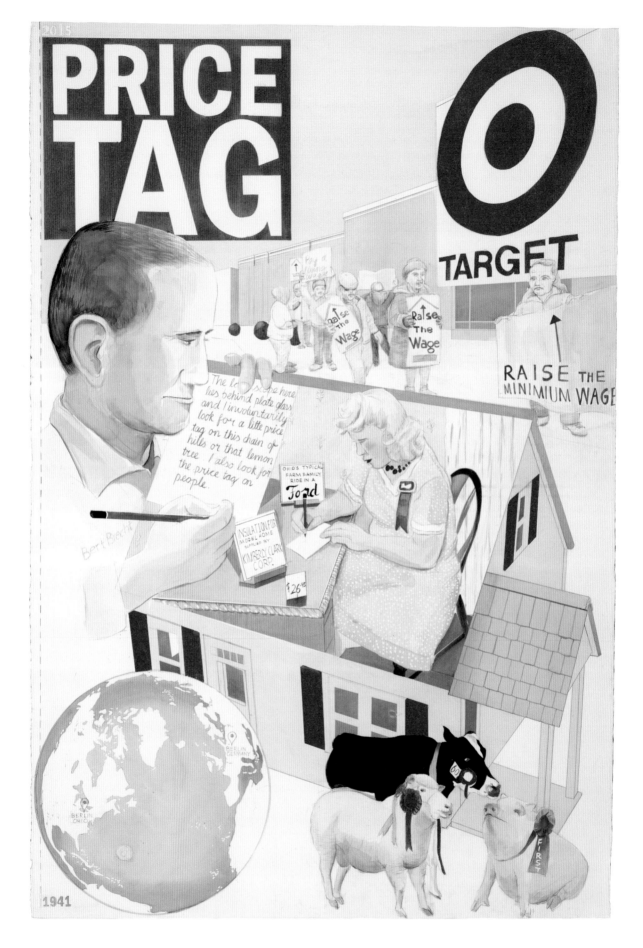

BERTOLT BRECHT BIBLIOGRAPHY

Brecht, Bertolt. "Against Georg Lukács," in *Aesthetics and Politics*. London and New York: Verso, 1997.

———. *Bertolt Brecht Letters*. Edited by John Willett. Translated by Ralph Manheim. New York: Routledge, 1990.

———. *Bertolt Brecht Poems Part Three 1938–1956*. Edited by John Willett and Ralph Manheim. London: Eyre Methuen, 1976.

———. *Brecht on Film and Radio*. Edited and translated by Marc Silberman. London: Methuen, 2000.

———. "The German Drama: Pre Hitler," *New York Times* (November 24, 1935).

———. *Journals 1934–1955*. Edited by John Willett. Translated by Hugh Rorrison. London: Bloomsbury Methuen Drama, 1993.

———. *The Measures Taken and Other Lehrstücke*. London: Methuen, 1977.

Brecht, Paul Flaig. "Chaplin and the Comic Inheritance of Marxism." *The Brecht Yearbook*: "Brecht/Marxism/Ethics," vol. 35 (2010).

Bunge, Hans, and Hanns Eisler. *Brecht, Music and Culture: Hanns Eisler in Conversation with Hans Bunge*. Edited and translated by Sabine Berendse and Paul Clements. London: Bloomsbury, 2014.

Hayman, Ronald. *Brecht: A Biography*. New York: Oxford University Press, 1983.

Lyon, James K. *Bertolt Brecht in America*. New Jersey: Princeton University Press, 1980.

SERGEI EISENSTEIN BIBLIOGRAPHY

Bulgakowa, Oksana. *Sergei Eisenstein: A Biography.* Berlin and San Francisco: Potemkin Press, 2001.

————. "Eisenstein, the Glass House and the Spherical Book: From the Comedy of the Eye to a Drama of Enlightenment." *Rouge* no. 7 (2005).

————, and Dietmar Hochmuth, editors. *Sergei Eisenstein: Disney.* Translated by Dustin Condren. Berlin and San Francisco: Potemkin Press, 2011.

Eisenstein, Sergei. *Notes of a Film Director.* Moscow: Foreign Languages Publishing House, 1946.

————. "Notes for a Film of *Capital*." Translated by Maciej Sliwowski, Jay Leyda, and Annette Michelson. *October*, no. 2 (Summer 1976).

————. *Film Form: Essays in Film Theory.* Edited and translated by Jay Leyda. New York: Harcourt, 1977.

————. "Chaplin's Vision," in *The Legend of Charlie Chaplin.* New Jersey: Castle, 1982.

————. *Essays in Film Theory.* Edited and translated by Jay Leyda. New York: Harcourt, 1977.

————. *Glass House—Du projet de film au film comme projet.* Dijon, France: les presses du réel, 2009.

Leslie, Esther. *Hollywood Flatlands: Animation, Critical Theory and the Avant-Garde.* London: Verso, 2002.

Leyda, Jay, and Zina Voynow. *Eisenstein at Work.* New York: Pantheon, 1982.

Montagu, Ivor. *With Eisenstein in Hollywood.* New York: International Publishers, 1974.

Seton, Marie. *Sergei M. Eisenstein.* New York: Grove Press, 1960.

Taylor, Richard, editor. *The Eisenstein Reader.* Translated by Richard Taylor and William Powell. London: British Film Institute, 1998.

ACKNOWLEDGMENTS

This project was possible because of the generosity and the creative commitment of many people. I would like to thank first and foremost my husband, Eric Muzzy. His contribution was much more than just cinematographer and model builder. Our ongoing dialogue shaped the project. From the beginning Christine Burgin's encouragement was invaluable; without her this book simply would not exist. Her ideas about the layout and visual design structure the book and give it coherence. I was delighted that Laura Lindgren agreed to design the publication and aid in editorial management. Her work is always so thoughtful. Thanks to Donald Kennison for his careful copyediting and proofreading. I also very much appreciate the help of Jason Burch, Ken Swezey, Mikaela Gross, Simona Jansons, and everyone at Asia Pacific Offset.

This project took me to many places, from Los Angeles to Moscow to the Midwest. In Los Angeles, I would like to thank everyone at the Velaslavasay Panorama: Sara Velas, Ruby Carlson, Oswaldo Podasa, and Jade Finlinson. The Panorama was our home away from home. I would also like to thank Maggie Cone and Xavier Henselmann for helping us put together a film crew. In Missouri I would like to thank Kathy Muzzy for showing us around the "zombie subdivisions."

My project could not have been accomplished without the support of the Bertolt Brecht Archive and the Russian State Archive for Literature and Art (RGALI). I would like to thank in particular Iliane Theiman at the Brecht Archive in Berlin and Iris Dankemeyer, who did research there on my behalf. The staff at RGALI in Moscow were invaluable in navigating the Eisenstein archive. In particular, I would like to thank the curator of exhibitions, Larissa Ivanova, for her very generous assistance. I could not have done this work without Tatiana Istomia, who set up our visit and translated for us at the archive.

A World Redrawn has had several incarnations. I would like to thank the curators who encouraged, supported, and advised me along the way. These include Edwin Carels at the International Film Festival Rotterdam, Karin de Jong at PrintRoom Rotterdam, Chelsea Haines and Francesco Scasciamacchia and Bid Project in Milan. I would like to thank Simonetta Cargioli at ESAM L'école supérieure d'arts & médias de Caen/Cherbourg.

Most especially I would like to thank Katherine Carl, curator of the James Gallery at the Graduate Center, City University of New York (CUNY), where

the complete *A World Redrawn* project was shown in the fall of 2015. Our ongoing discussions over a couple of years were very important. I would also like to thank Jennifer Wilkinson, exhibitions coordinator, for all her hard work and her wonderful ability to stay calm. The show at the Graduate Center would not have happened without the support of Amy Herzog, who cosponsored the exhibition through "Mediating the Archive," her Mellon Seminar in Public Engagement and Collaborative Research in the Humanities at the Graduate Center. This book grew out of lectures and discussion that were sponsored by the Mellon Seminar, which included Hannah Frank and Esther Leslie.

 A World Redrawn was supported by the Graham Foundation for Advanced Studies in Fine Arts. Additional support was provided by the Media Arts Assistance Fund for Artists, a regrant program of the New York State Council on the Arts, Electronic Media and Film, with support of Governor Andrew Cuomo and the New York State Legislature, administered by Wave Farm; the Dean's Research Enhancement Grant, Queens College CUNY; and the PSC-CUNY Research Award. Resources and honoraria from ESAM and the Amie and Tony James Gallery were also invaluable in realizing the artwork.

 Finally I would like to thank the actors Kate Valk and Jim Fletcher for their amazing contribution to *Glass House*, Bryan Yoshi Brown and Ben Taylor for their seriousness and commitment during the filming of *Two Marxists in Hollywood*, the voice performances of Vladimir Weigl and Anthony Wellman, composer Susie Ibarra for her score, and the musical contribution of the extraordinary Hannah Temple to *A Model Family in a Model Home*.

ABOUT THE AUTHORS

Zoe Beloff is an artist working in film, installation, and drawing. She has edited three other books published by Christine Burgin: *The Somnambulists: A Compendium of Source Material* (2008), *The Coney Island Amateur Psychoanalytic Society and Its Circle* (2009), and *Adventures of a Dreamer by Albert Grass* (2010). She is a professor at Queens College CUNY.

Hannah Frank is a doctoral candidate in Cinema and Media Studies at the University of Chicago, where she is writing a dissertation on the art, labor, and technology of animated cartoons. Her article "Traces of the World: Cel Animation and Photography" appears in the March 2016 issue of *Animation: An Interdisciplinary Journal*. Her other research interests include early Soviet cinema, found-footage documentaries, and the history of special effects.

Esther Leslie is Professor of Political Aesthetics in the Department of English and Humanities at Birkbeck, University of London. Her research interests include Marxist theories of aesthetics and culture, with a particular focus on the work of Walter Benjamin and Theodor Adorno. Other research interests include the poetics of science, European literary and visual modernism and avant-gardes, animation, color, and madness. Her books are *Walter Benjamin: Overpowering Conformism* (Pluto 2000), *Hollywood Flatlands: Animation, Critical Theory and the Avant-Garde* (Verso 2002), *Synthetic Worlds: Nature, Art and the Chemical Industry* (Reaktion 2005), *Walter Benjamin* (Reaktion 2007), and *Derelicts: Thought Worms from the Wreckage* (Unkant, 2014). Her translations include Georg Lukacs, *A Defence of 'History and Class Consciousness'* (Verso 2002) and *Walter Benjamin: The Archives* (Verso 2007). Her next book is on the poetics and politics of liquid crystals.

Eric Muzzy is a longtime collaborator on Beloff's projects, as a cinematographer, lighting designer, architectural model builder, and technical director. He started his young professional life peripatetically in a series of pursuits including factory worker, cabinet maker, house builder, deckhand, and television cameraman, and more recently settling somewhat on work in film and in lighting for theater and performance and as a programmer and librarian. Eric envisions the same wandering spirit in a more mature professional life yet to come.

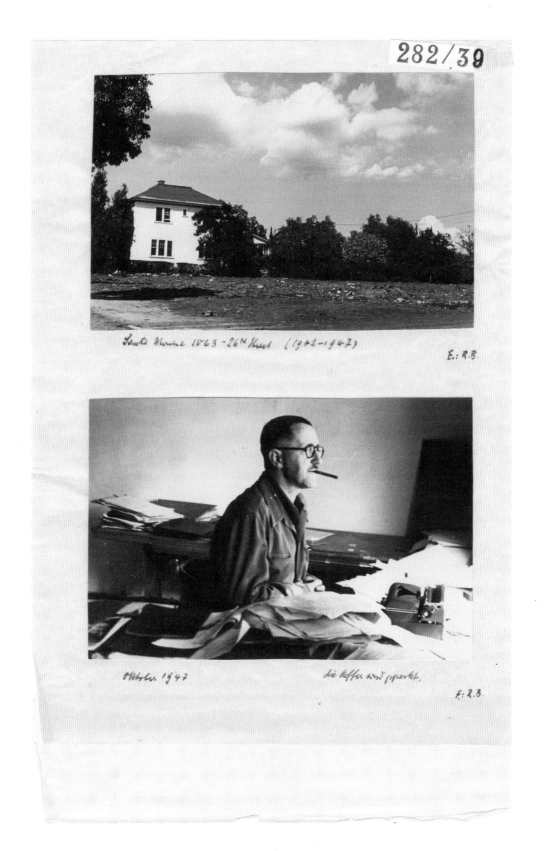

Bertolt Brecht, journal entry, October 1947. Top: Santa Monica 1063 26th Street (1942–1947). Bottom: The suitcases are packed. Photographs by Ruth Berlau.

A World Redrawn
Edited by Zoe Beloff
2016

A World Redrawn © 2015 Zoe Beloff
Two Marxists in Hollywood © 2015 Zoe Beloff
Glass House © 2014 Zoe Beloff
The Potential of Pochta © 2015 Hannah Frank
A Model Family in a Model Home © 2015 Zoe Beloff
Those in Glass Houses Laugh © 2015 Esther Leslie

ISBN: 978-0-9778696-8-8

Book design and composition by Laura Lindgren
The text of this book is composed in Twentieth Century.

Printed and bound in China through Asia Pacific Offset

Front and back covers, endpapers, and pages 6, 7, 9, 39, 40–63, 69, 83–97, 113, 120–30, 132,
133, 135, 137, 139, 141, 143, 144, 146: © Zoe Beloff
Pages 2, 4, 18, 25, 27, 29, 66, 71–81: Russian State Archive of Literature and Art (RGALI), Moscow
Pages 13–15 and 151: © Bertolt Brecht, edited by John Willett, translated by Hugh Rorrison,
Bertolt Brecht Journals 1934–55, used by kind permission of the Brecht Estate and Bloomsbury
Methuen Drama, an imprint of Bloomsbury Publishing Plc.
Pages 15 and 151: photographs © Ruth Berlau/Hoffmann
Page 23 (right): Sputnik/Science Photo Library
Page 30: Reproduced from the original held by the Department of Special Collections of the
Hesburgh Libraries of the University of Notre Dame
Page 65: Collection Christine Burgin
Page 98: Collection Zoe Beloff
Page 115: © Bertolt-Brecht-Erben/Suhrkamp Verlag

Published by Christine Burgin
239 West 18th Street
New York, NY 10011
www.christineburgin.com